Lost Restaurants
of
FORT WORTH

Lost Restaurants
of
FORT WORTH

CELESTINA BLOK

AMERICAN PALATE

Published by American Palate
A Division of The History Press
Charleston, SC
www.historypress.net

Front cover, top left: W.D. Smith Photography Collection, Special Collections, the University of Texas at Arlington Libraries, Arlington, Texas; *center*: photo by Craig Howell, www.fortworthyesterday.com; *right*: Judith S. Cohen; *bottom*: W.D. Smith Photography Collection, Special Collections, the University of Texas at Arlington Libraries, Arlington, Texas. *Back cover, top left*: W.D. Smith Photography Collection, Special Collections, the University of Texas at Arlington Libraries, Arlington, Texas; *top right*: Fort Worth Star-Telegram Collection, Special Collections, the University of Texas at Arlington Libraries, Arlington, Texas; *bottom*: Fort Worth Star-Telegram Collection, Special Collections, the University of Texas at Arlington Libraries, Arlington, Texas.

First published 2017

ISBN 978-1-5402-2777-5

Library of Congress Control Number: 2017953979

To Bo Ray Blok, my firstborn baby. I became aware of your presence approximately two weeks after I committed to this project, and for the next nine months we journeyed together to libraries and interviews and on jaunts around town, researching and studying Fort Worth's restaurant past for hours on end. You were an angel throughout the entire process, providing me energy, clarity and inspiration— never slowing me down. Even more, you arrived just hours after I completed the manuscript. It was as if you timed it that way. Thank you for being so cool.

CONTENTS

ACKNOWLEDGEMENTS

T hank you first and foremost to Ben Gibson, commissioning editor at The History Press, who reached out to me about this project, met me for breakfast at Paris Coffee Shop in Fort Worth and was ever so patient and encouraging throughout the entire process. I hope to work with him again.

Having been born in 1979, years after many of the restaurants listed in this book came and went, it was crucial for me to rely on the guidance and many anecdotes of longtime Fort Worth residents. Getting started would have been nearly impossible without the help of Jack Miller and Barry Rubin. Both Fort Worth natives and prominent business owners, these two good friends immediately provided me with a detailed list of lost restaurant prospects along with contact information for anyone still around related to these venues. They were happy to do so out of their own kindness and excitement for the project and never asked for any credit.

Tarrant County Archives connected me with Dalton Hoffman, a Fort Worth native and avid collector of historic memorabilia. I visited Mr. Hoffman at his home, where he enthusiastically shared dozens of postcards and menus he'd collected at estate sales over the years. A volunteer for Tarrant County Archives, Hoffman said restaurants and businesses used postcards as an inexpensive way to market themselves in the mid-twentieth century, decades before the Internet and social media. Having never met me before, Hoffman still graciously allowed me to borrow his treasured restaurant keepsakes for as long as I needed in order to study and scan them.

ACKNOWLEDGEMENTS

The book would also not be possible without the assistance of Cathy Spitzenberger, photo collections specialist at the University of Texas at Arlington. I gave her my restaurant list, and she kindly pulled countless negatives out of the library's extensive archive collection. With cotton gloves on and a magnifying glass in hand, I examined each one under her supervision.

Another key player in the completion of this project is Bud Kennedy. Readers of the *Fort Worth Star-Telegram* know him for his "Eats Beat" column. Kennedy is the king of Fort Worth dining news, having covered the topic for more than three decades. I am thankful not only for his advice and support but also for his hundreds of restaurant columns, from which I cite regularly throughout this book.

I am also much indebted to Adam Jones, owner of two premier downtown Fort Worth restaurants: Grace and Little Red Wasp. Jones coordinated and hosted lunch for my extensive interview with Walter Kaufmann, who opened the Old Swiss House in 1964. The Swiss chef remains involved in the city's restaurant scene today and is considered an icon for his contributions to educating Fort Worth's culinary palate. At the time of our interview, he was eighty-eight years old. I am grateful to have sat across from him to hear about his journey and his own recollections of Fort Worth's restaurant past.

Additional thanks go to Historic Fort Worth, Inc., a nonprofit organization dedicated to preserving the city's unique historic identity through stewardship, education and leadership. Its team connected me with Judith Cohen, author of *Cowtown Moderne: Art Deco Architecture of Fort Worth, Texas*, who graciously provided rare interior shots of Topsy's Café from her personal collection.

There were many other players involved, including Pam Benson, whose father, Dave Benson, helped kick-start the drive-in era in Fort Worth in the 1950s with his Lone Star Drive-Ins and later opened several other successful restaurant concepts. Pam shared many stories with me and let me borrow precious memorabilia, including menus and photos, for my research.

Thanks also to Fort Worth historian Quentin McGown; John Cirillo, owner of www.fortworthyesterday.com; Jan Shaffer, whose family established the Italian Inn; Larry Brown, founder of the popular "Closed and Forgotten Cowtown Eateries" Facebook page; Steve Murrin, whose father was one of Fort Worth's first restaurateurs; Mike Nichols, author of *Lost Fort Worth*; and my dad, David Phillips, who recalled memories from his teenage years working at the Farmer's Daughter with great detail.

ACKNOWLEDGEMENTS

Finally, the book would most certainly not be possible without the *Fort Worth Star-Telegram*. While newspapers might currently be on the decline nationwide, they are crucial to the documentation and preservation of our cities' storied pasts. I spent hours searching the *Star-Telegram*'s online archive newsbank, which dates to the early 1900s. It offers a wealth of valuable and precious information, thanks to yesterday's dedicated journalists.

INTRODUCTION

There are two things folks from Fort Worth know for sure: the city slogan is "Where the West Begins," and the city is most certainly not Dallas.

A bit of history: In 1849, U.S. Army major Ripley Arnold, per his commander's orders, planted a U.S. flag on the future site of Fort Worth, near the convergence of two forks of the Trinity River. A fort was built, named for Major General Williams Jenkins Worth, and Tarrant County was created by the state legislature. Settlers were soon attracted by rich soil and the army's security.

In 1853, the fort was vacated as troops were redeployed to make a push toward the Pacific Ocean. Residents converted the military buildings left behind into schools, stores and churches, and trade and business began to thrive. Fort Worth elected its first mayor, Dr. W.P. Burts, in 1873.

In the years that followed, Fort Worth became a major trading point, as it stood on the main route of the Chisholm Trail, where herds of longhorns were driven from Texas to Kansas. A red-light district notoriously dubbed "Hell's Half Acre" sprang up, and bawdy behavior involving pistol-firing cowboys and lewd ladies ensued.

The first Fat Stock Show (today known as the Fort Worth Stock Show & Rodeo) was held in 1896. By the turn of the century, the city was booming. The population in 1900 was approximately twenty-six thousand. That's twenty thousand more than in 1880.

This is when we began to see promotion of some of Fort Worth's first restaurants, via ads in the *Fort Worth Morning Register*. An 1897 ad for the

White Elephant Restaurant at 604–606 Main Street boasted a fish-heavy menu of lake trout, Spanish mackerel, black bass, Gulf trout, lobster, redfish and pickerel. "Stop here for good dinner or lunch," the ad stated. A reincarnated White Elephant Saloon, now owned by celebrity chef Tim Love, exists today in the Fort Worth Stockyards.

But Fort Worth quickly became known for beef rather than fish, thanks to multiple meatpacking houses that arrived in 1902, including Swift & Company, Armour & Company and McNeill & Libby. Fort Worth, now nicknamed "Cowtown," became the meatpacking hub of the Southwest.

This glimpse into history provides a peek at the origins of Fort Worth's restaurant past. The beef industry, the red-light district and the arrival of immigrants from around the world attracted to such an economically sound city all helped shape Fort Worth's earliest culinary roots.

Longtime restaurateurs, including L.O. Fuqua of Fuqua's meat market, grocery store and coffee shop and Theo Yordanoff of Theo's Saddle & Sirloin Inn, started their businesses early in the twentieth century. The Richelieu Grill began even earlier, sometime between 1885 and 1895, and lasted all the way until 1991. And a Chinese man named Eng Wing (who somehow became known as "Murphy") turned a popular downtown saloon into an internationally recognized Cantonese restaurant after the institution of Prohibition in 1918. That restaurant later evolved into the Bamboo Inn.

Fast-forward to today. Having written about restaurants in rapidly growing Fort Worth for more than a decade, my focus has always been on everything new. Through a monthly restaurant column and local recipe feature stories, I share all that I can uncover about the latest and greatest culinary finds. What are this season's trends in cooking wild game? What chef left what restaurant, and where is he or she going next? What new cocktail is sweeping the bar scene? What's the latest concept going into that cursed shopping center corner that keeps changing tenants?

I frantically try to stay on top of breaking restaurant news via social media and Internet searches. I even check if "for lease" signs have been replaced by Texas Alcoholic and Beverage Commission signage informing residents that the applicant is requesting a liquor permit—usually a sign that a new restaurant is coming soon. And my inbox is frequently flooded with press releases from local public relations firms seeking coverage of what's happening with their endless list of restaurant clients.

In today's climate of instantaneous news, what's new is what readers want. Every "foodie" hopes to be the first to try the latest hip eatery and share their mouthwatering pics on Instagram.

Although I am a native, rarely (like most area diners my age) did I think much about the long-shuttered Fort Worth restaurants—until I was approached about writing this book.

Sure, I had a strong appreciation for Fort Worth mainstays like the eighty-two-year-old Joe T. Garcia's, the fifty-nine-year-old Angelo's Bar-B-Que and landmark restaurants like Paris Coffee Shop, El Rancho Grande and Cattlemen's Steak House. These establishments still operate today and have drawn regulars for decades.

But, upon embarking on my research of Fort Worth's iconic restaurant past, I quickly learned that long-lost restaurants still very much pull at the heartstrings of many longtime Fort Worth residents while also triggering nostalgic pangs of hunger. Social media pages dedicated to "Closed and Forgotten Cowtown Eateries" and "Fort Worth Memories" have tens of thousands of followers, many of whom reminisce regularly about their favorite dives and dishes. It seems the faster Fort Worth grows, the more residents long for a taste of the good old days.

I sincerely hope this book will allow those who frequented these restaurants to recall fond memories and experience a bit of pleasure in reading about what made them iconic. Perhaps, readers may also learn something they didn't know.

Speaking of the restaurants, by no means are all that were considered iconic included. As I spoke to longtime Fort Worth residents, many of them community leaders and successful business owners themselves, as well as local history buffs and avid memorabilia collectors, I received the names of dozens of recommended restaurants to include.

Over and over, I was asked if I "got the one" on University Drive, on Main Street, on the North Side, on Camp Bowie Boulevard, on Berry Street and many more. I soon realized that including all that were mentioned was just not possible, so I narrowed down the list to the places that were brought up most often. Then I further narrowed the list to places for which I could find images or memorabilia of any sort.

So, sit back and savor this small but hearty portion of some of Fort Worth's gone but not forgotten favorites; and if you take anything away, may it be to never take for granted the restaurants you cherish today.

THE INFLUENCE OF THE IMMIGRANT

P art of Fort Worth's history is the great immigrant families who have come here and opened restaurants," said longtime *Fort Worth Star-Telegram* food columnist Bud Kennedy during a 2014 speaking engagement on the city's iconic restaurants presented by the Fort Worth Library. "The Stockyards brought all kinds of cultures: Germans, Eastern Europeans, Russians, people from Mexico. People from all over the world came to work in the Stockyards and those people brought all kinds of food culture to the North Side. [They] also embraced the culture of beef and left their own mark on beef and cooking in Fort Worth."

When large herds came through Fort Worth via the Chisholm Trail, a railroad, meatpacking industry and stockyards were established. Immigrants came from Central Europe to work in the plants. By 1915, during the heat of World War I, soldiers in uniforms from up to fifteen different countries purchased horses and mules for their armies. The Fort Worth Stockyards became the largest horse and mule market in the country. In 1917, 3.5 million animals of all types arrived. The livestock industry helped fuel Fort Worth's appeal to people from around the world.

BAMBOO INN

Steaks and Chinese food may be considered an odd combination for a restaurant concept, but it worked for the Bamboo Inn. However, the collaboration didn't happen intentionally, at least at first.

Bamboo Inn's origins began with the historic Seibold Hotel, opened on May 31, 1907, in downtown Fort Worth at Seventh and Rusk (now Commerce) Streets. The building, which was completely gutted and updated with a new interior layout, had previously been used for the medical department of Fort Worth University and, before that, as the county courthouse. Two more stories were eventually added, and an elevator was installed.

Opened by Iowa native Edward Seibold, the hotel was reported to be the first in Fort Worth with hot and cold water and a telephone in every guest room, as well as large ceiling fans. It became "an outstanding stopping place for cattlemen," John Fincher told the *Fort Worth Star-Telegram* in 1954.

While many out-of-town guests visited for Fort Worth's stock show and soldiers arrived at Camp Bowie during World War I, the hotel began attracting patrons for its dining room, including high-profile individuals such as bank presidents. "First-class meals at all times" were served, reported the *Fort Worth Star-Telegram*.

Seibold lost his popular hotel saloon in 1918 thanks to a statewide prohibition amendment. Profit losses were sure to be substantial. But that

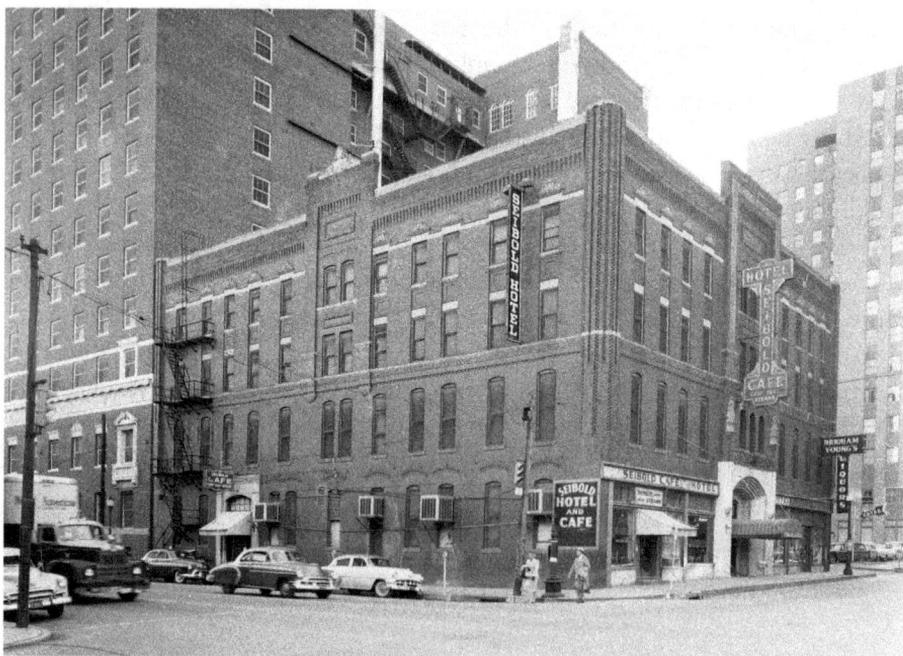

Seibold Hotel and Café at Seventh and Rusk (now Commerce) Streets in 1954. *Fort Worth Star-Telegram Collection, Special Collections, the University of Texas at Arlington Libraries, Arlington, Texas.*

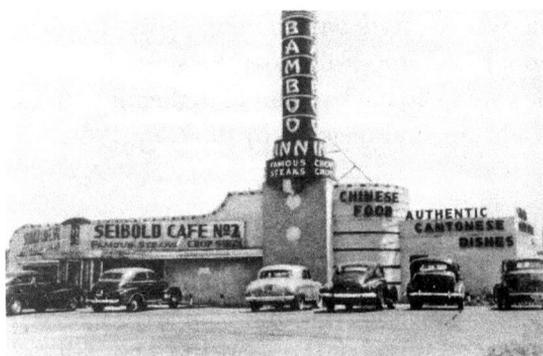

Left: Bamboo Inn & Seibold Café No. 2 at Camp Bowie Boulevard and Horne Street in 1949. *Quentin McGown.*

Below: Bamboo Inn & Seibold Café advertisements, 1953. *From the* Fort Worth Star-Telegram.

COME TO THE
BAMBOO INN
FOR THE FINEST
CHRISTMAS DINNER
and STEAKS
OPEN CHRISTMAS DAY AT 9 A.M.
5701 CAMP BOWIE BLVD.
AT WEST END OF EAST WEST EXPRESSWAY
PHONE PE-3942

CELEBRATE WITH A
TURKEY or STEAK DINNER
AT

SEIBOLD CAFE NO. 1
804 Commerce
(Downtown)

OR

SEIBOLD CAFE NO. 2
(BAMBOO INN)
West End of Expressway
5701 Camp Bowie

OPEN 11:00

same year, a man named Eng Wing from China took over the former saloon space, turned it into a café with an entrance on Commerce Street and introduced customers to Chinese cuisine. Eng, whose name was actually spelled Ng, became known to customers as "Murphy," which was easier for them to say and spell. And while the establishment was officially named Seibold Café, most patrons called it "Murphy's Place."

"That café was destined to become internationally known," wrote *Fort Worth Star-Telegram* writer Blair Justice in 1954. "And it repaid Seibold more than it lost with the closing of the saloon."

English fliers, stationed in Fort Worth for training during World War II, purportedly visited the café after hearing about its famed steaks in Europe. Movie stars and celebrities, including Bob Hope and Gene Autry, would also dine there when in town.

Fort Worth historian Quentin McGown wrote in his book *Fort Worth in Vintage Postcards* that Eng's family members continued to run the downtown café and eventually expanded to a second location at the intersection of Camp Bowie Boulevard and Horne Street.

"Famous steaks, chop suey and authentic Cantonese dinners" were advertised on building signage, which featured a distinctive tower that proclaimed "Bamboo Inn" in bold letters.

The Seibold Hotel building was torn down to make way for new development in 1955. The Seibold Café moved across the street but later closed. Murphy had long left the café to go back to China in the mid-1920s. The Bamboo Inn and Seibold Café No. 2 also closed by the early 1960s.

JIMMIE DIP'S

Another Cantonese man came to Fort Worth from China and served Chinese food to hungry patrons for years after Bamboo Inn and Seibold Café shuttered their doors.

Jow Ming Dip, better known as "Jimmie Dip" (or "Jimmy Dip"—both spellings were prevalent in newspaper articles and ads), opened his namesake restaurant in 1961 after moving to Fort Worth in the mid-1940s. He had started with the Blue Star Inn, a Chinese food mainstay with locations on Camp Bowie Boulevard and Alta Mere at Highway 183, but it was Jimmie Dip's, which thrived for more than three decades, that most restaurant patrons remember.

"True Chinese food lovers and even the adventurous might view Jimmy Dip's as a place to go," wrote Nancy Weatherly in her *Fort Worth Star-Telegram* restaurant review in 1976. "Jimmy Dip's is right up middle class America's alley. Casual dress seemed to be the fashion and meals were medium-priced."

Located at 1500 South University Drive in a former gas station, Jimmie Dip's drew crowds for chow mein, egg foo yong, Peking duck, sweet and sour pork, charbroiled steaks and even cinnamon rolls. Also popular, at least in the 1970s, was the Jimmie Dip combo, featuring chicken livers and ham. The restaurant was open late, until midnight on the weekends.

"Jimmie Dip's was just across the street from Ol' South Pancake House," said Pam Benson, whose father, Dave Benson, owned the twenty-four-hour diner. "University Drive had a row of restaurants in that area. Its popularity was that it was probably one of the first Chinese restaurants in Fort Worth at that time. Remember, there was not the plethora of restaurants as there are today. It had its mystique; fortune cookies and unfamiliar decor to the average Fort Worth patron."

Dip had made headlines in 1952 for catching a four-pound black bass in Lake Worth, at a time when it was apparently unknown if the lake even held fish. He used a "big minnow" and got the fish in "after a short fight," the *Fort Worth Star-Telegram* reported.

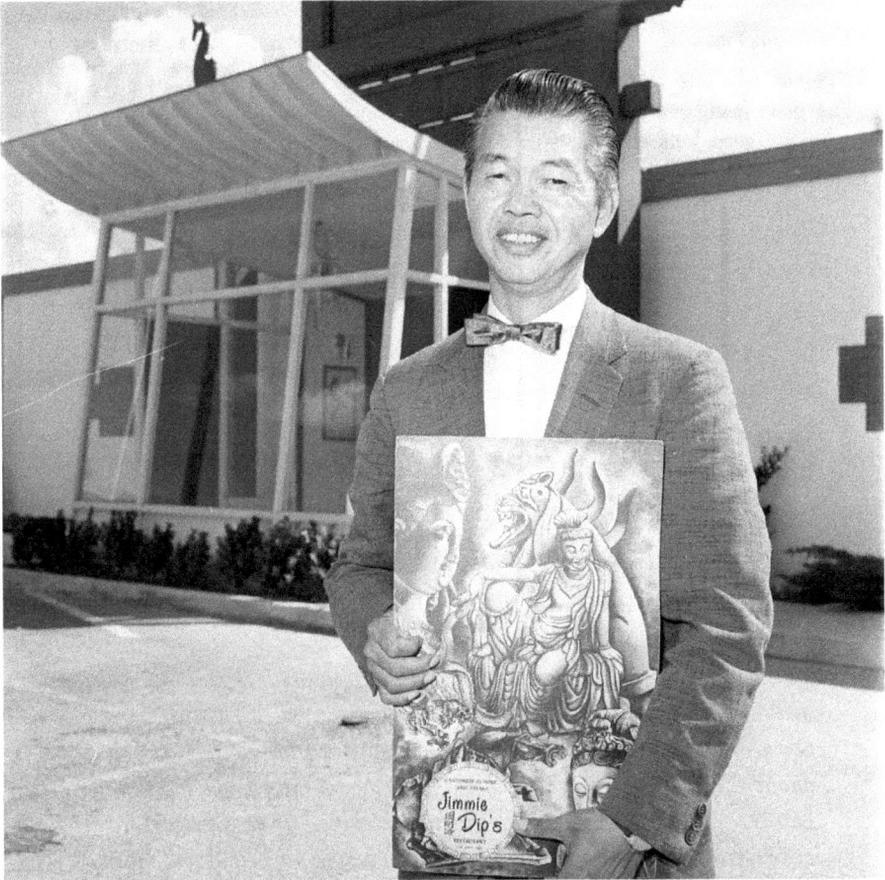

Jimmie Dip stands outside his newly opened namesake restaurant at 1500 South University Drive, 1961. *Fort Worth Star-Telegram Collection, Special Collections, the University of Texas at Arlington Libraries, Arlington, Texas.*

Even after Dip himself passed away at age sixty-one of an apparent heart attack in 1973, family members continued to successfully run the restaurant, all the way through the early 1990s.

A 1981 *D Magazine* review sang the restaurant's praises:

> *Jimmie died, and for a while, it was easy to forget this longtime Chinese restaurant. But Jimmie Dip's is still in business: The food remains excellent, the service superb, and the decor unassuming and tasteful. We began, of course, with fried wontons all around, and then opted for the Chinese vegetable soup. Both were supreme appetizers. Our main dish*

Confucious say:

"Person who like football like good food, and person who like good food eat at JIMMY DIP'S."

This ancient Chinese proverb that we just now made up may not be authentic, but it makes good sense, and the Chinese food served at Jimmy Dip's is authentic and delicious, too. So make your football day complete by joining the crowds at Jimmy Dip's, before or after the game, for the finest in Chinese food and steaks. Open 11:00 a.m. to 11:30 p.m.; Saturday, 12 noon to 12 midnight.

Jimmie Dip's

1500 SOUTH UNIVERSITY
ED 6-4333 for Orders to Go!

OUT OF RESPECT TO THE MEMORY OF

JOW MING DIP

OWNER

WE WILL BE CLOSED UNTIL TUESDAY, APRIL 3 OPEN 4:00 P.M.

JIMMIE DIP'S

1500 SOUTH UNIVERSITY

Above: Jimmie Dip's advertisement after Dip's death in 1973. *From the* Fort Worth Star-Telegram.

Left: Jimmie Dip's advertisement, 1965. *From the* Fort Worth Star-Telegram.

was the almond gai ding, diced white chicken meat with snow peas, water chestnuts, bamboo shoots, and mushrooms—so good, we hated sharing. Other dishes we sampled included the war sui har (breaded jumbo shrimp wrapped in bacon), the sweet and sour pork, the ginger beef, and the Jimmie Dip special, which is a mixture of chicken, chicken livers, Virginia ham, and vegetables, sautéed in chicken broth—an unlikely dish that was the best of the evening. This restaurant knows what it's doing.

But in 1994, owners listed the 4,300-square-foot space for sale or lease as they prepared for retirement. South University Drive was changing its landscape as the development of nearby University Park Village continued with its tony shops and newer, flashier restaurants. On social media forums recalling some of Fort Worth's most beloved eateries of the past, Jimmie Dip's is most certainly one of the most cited.

BLUE STAR INN

"We used to go to Blue Star Inn on Sundays after church lots of times for their delicious sweet and sour pork and fried rice," said Fort Worth mayor Betsy Price.

She wasn't alone. The Blue Star Inn was a bastion of Chinese cuisine from the early 1940s through the late 1970s, with two prominent locations in West Fort Worth. The first was established at 5716 Camp Bowie Boulevard by 1942. That's the year Blue Star Inn ads began appearing in the *Fort Worth Star-Telegram* boasting steaks as the restaurant specialty.

In 1948, a more modern Blue Star Inn No. 2 opened on Highway 183 at Alta Mere Drive on the traffic circle. Opening-day ads declared that the restaurant's chefs came "from a long line of outstanding gastronomic experts."

Joe Foo, better known in Fort Worth as Jimmie Joe, had emigrated from Canton, China, at the age of fourteen, according to Juliet George's book *Camp Bowie Boulevard*. He served in the U.S. Army during World War II before opening his restaurant with relatives, having previously served as the personal cook of General George Patton, as one Blue Star Inn ad proclaimed.

While the restaurant liked to boast its steaks early on, most patrons remember the Cantonese cuisine, including moo goo gai pan, or chicken and mushrooms with snow peas and a special sauce, and the chop suey, made with beef tenderloin, mushrooms and seasonal vegetables.

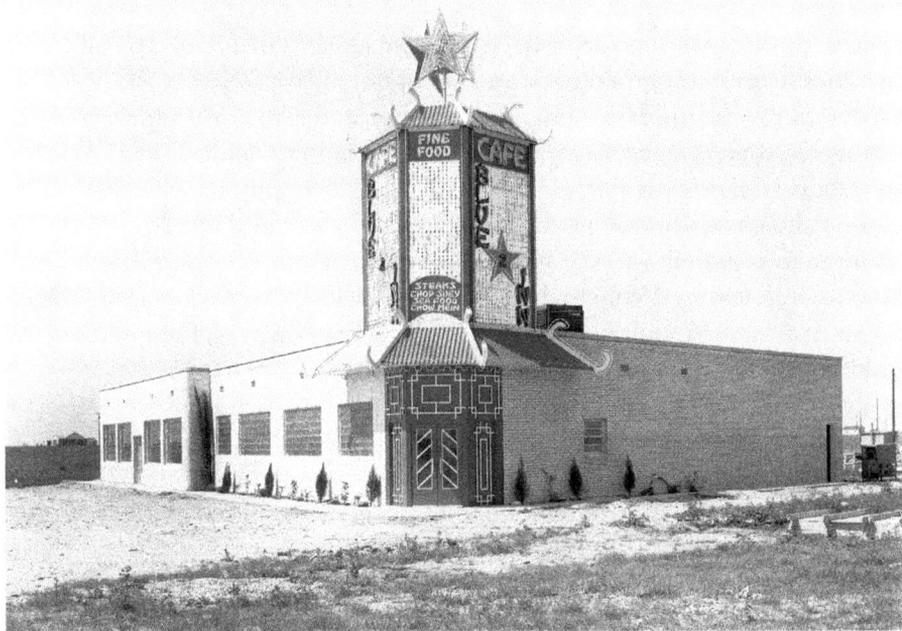

Blue Star Inn No. 2 at 3500 Alta Mere Drive in 1948. *W.D. Smith Photography Collection, Special Collections, the University of Texas at Arlington Libraries, Arlington, Texas.*

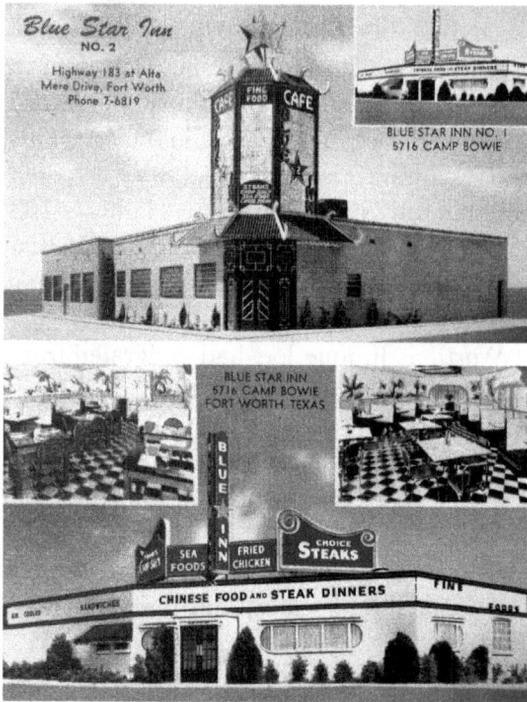

Blue Star Inn NO. 2
Highway 183 at Alta Mere Drive, Fort Worth
Phone 7-6819

BLUE STAR INN NO. 1
5716 CAMP BOWIE

BLUE STAR INN
5716 CAMP BOWIE
FORT WORTH, TEXAS

SEA FOODS FRIED CHICKEN CHOICE STEAKS

CHINESE FOOD AND STEAK DINNERS

Top: In 1948, Blue Star Inn No. 2 opened on Highway 183 at Alta Mere Drive. Opening-day ads declared that the restaurant's chefs came "from a long line of outstanding gastronomic experts." *Dalton Hoffman.*

Bottom: The first Blue Star Inn was established at 5716 Camp Bowie Boulevard in 1942. *Dalton Hoffman.*

Perhaps the most popular dish was the war su har, a meal not typically seen on Chinese restaurant menus today, at least not in Fort Worth. Composed of bacon-wrapped shrimp fried in a spicy batter and served with tomato aspic and green onions, the dish was regularly recommended by *Texas Monthly* magazine.

After the Camp Bowie location experienced a fire in the early 1960s, the restaurant was rebuilt with a slightly updated name: the Blue Star Restaurant. Menu items featured charcoal-broiled and hickory-smoked steaks, lobster tail and Rocky Mountain rainbow trout. Even with the high-end menu additions, folks still flocked for the Chinese food.

"I am addicted to Cantonese chow mein. Every two or three weeks—certainly no longer than a month—I must go to the Blue Star Restaurant for a fix," wrote *Fort Worth Star-Telegram* food critic Sandra Hawk in 1977.

The restaurant's pan-fried soft noodles mixed with chunks of chicken cost $4.65 at the time.

"I can get enough to keep me going for another few weeks," Hawk continued.

At lunch, an all-you-can-eat buffet with six selections, salad and a drink cost $2.50.

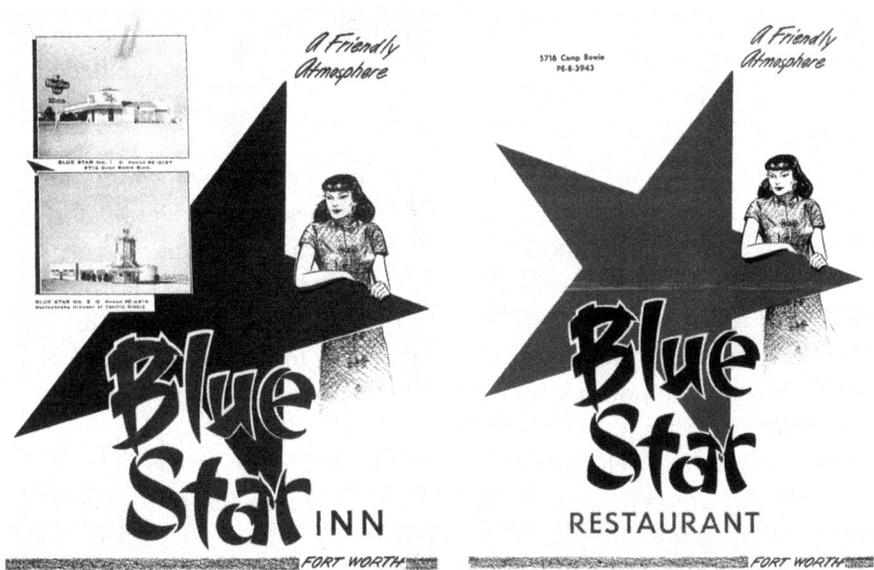

Left: Blue Star Inn menu. *Dalton Hoffman.*

Right: Blue Star Restaurant menu. *Dalton Hoffman.*

Despite drawing crowds through the late 1970s, a reincarnation of the Blue Star on Camp Bowie Boulevard had opened under new ownership by 1981. The new name was the Blue Star Oyster Company. Gone for good were the chow mein, chop suey and war su har, replaced by fried seafood baskets, broiled redfish and Gulf trout. The restaurant was short-lived, and a Mexican Inn later opened at the landmark location and still operates there today.

THEO'S SADDLE & SIRLOIN INN

Whether referred to as mountain oysters, prairie oysters or calf fries, or called by their actual definition—the testicles of a young bull—Theo's Saddle & Sirloin Inn in the Fort Worth Stockyards was the first restaurant to ever put this item on a menu.

"Now cowboys always ate calf fries because cowboys ate just about every part of the calf that they could down on the trail, and they actually considered them a little bit of a delicacy," said *Fort Worth Star-Telegram* columnist Bud Kennedy during his 2014 lecture on the city's iconic restaurants for the Fort Worth Library.

But when a West Texas cowboy walked into young Theo Yordanoff's lunch café in the early 1920s and asked for mountain oysters, the fledgling restaurateur had no idea what he was talking about. So, he asked and received an explanation.

"They're what separate the bulls from the cows," the cowboy told him.

Yordanoff decided to be ready the next time they were ordered.

Kennedy said that Yordanoff, an immigrant from Macedonia who arrived to the United State on the *Lusitania* in 1914, went to Stockyards meatpacking houses and asked for a deal on the uncommon cut of cattle. He was told he could have all he wanted for free. According to a 1983 *Fort Worth Star-Telegram* article by reporter Christopher Evans, he started selling mountain oyster sandwiches for ten cents each.

"But he couldn't spell 'mountain' and he couldn't spell 'oyster,'" wrote Evans. "Furthermore, the small blackboard menu on the wall wasn't big enough to accommodate the words even if he could have spelled them. Hence, Yordanoff called them 'calf fries.' On one hand, the term was easier to spell. On the other, it sounded a bit more palatable than mountain oysters."

Theo's Café moved from 110 East Exchange Avenue to 120 East Exchange Avenue by the 1940s. The restaurant was now famous for its calf fries.

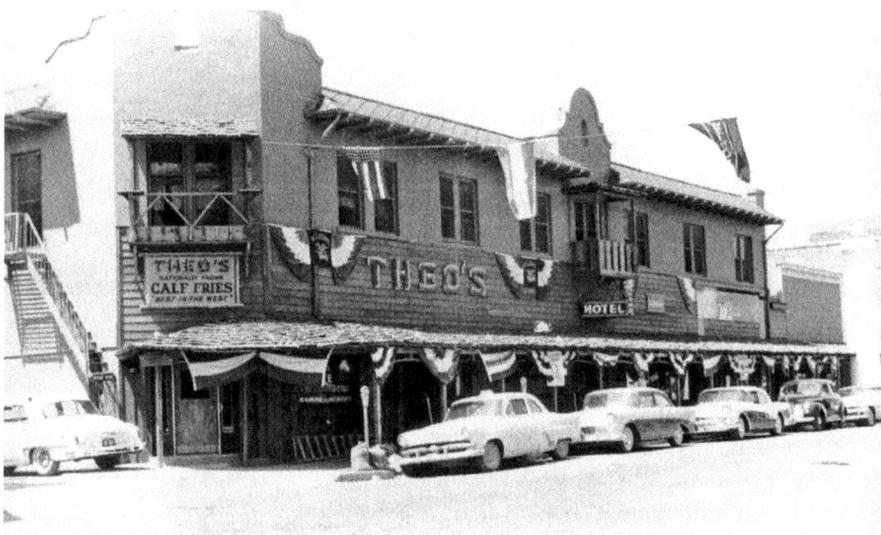

Theo's Café exterior, 1958. *Joe Riscky.*

"If a customer asked what they were, Yordanoff would just smile and say, 'They're fresh from the tree,'" Kennedy said.

Yordanoff didn't know he would pioneer a tradition that would carry on for more than a century. Today, several high-profile Fort Worth restaurants proudly serve calf fries on their menus, including Horseshoe Hill, Reata, Fred's Texas Café, M&M Steak House and Cattlemen's Steak House.

Yordanoff later grew his namesake restaurant into a destination of national acclaim with almost theme park status—literally. Theo's Café reopened in

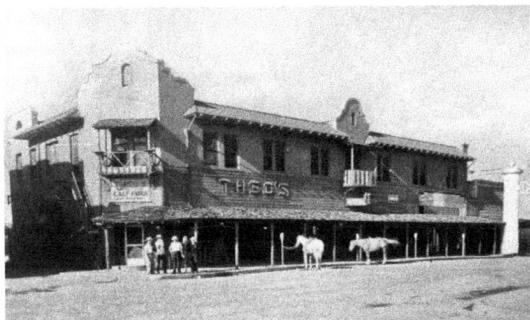

Left: Theo's Café postcard. *Dalton Hoffman.*

Below: Theo's Café reopened in 1959 as Theo's Saddle & Sirloin Inn, with a new interior design by a Disneyland architect. *Joe Riscky.*

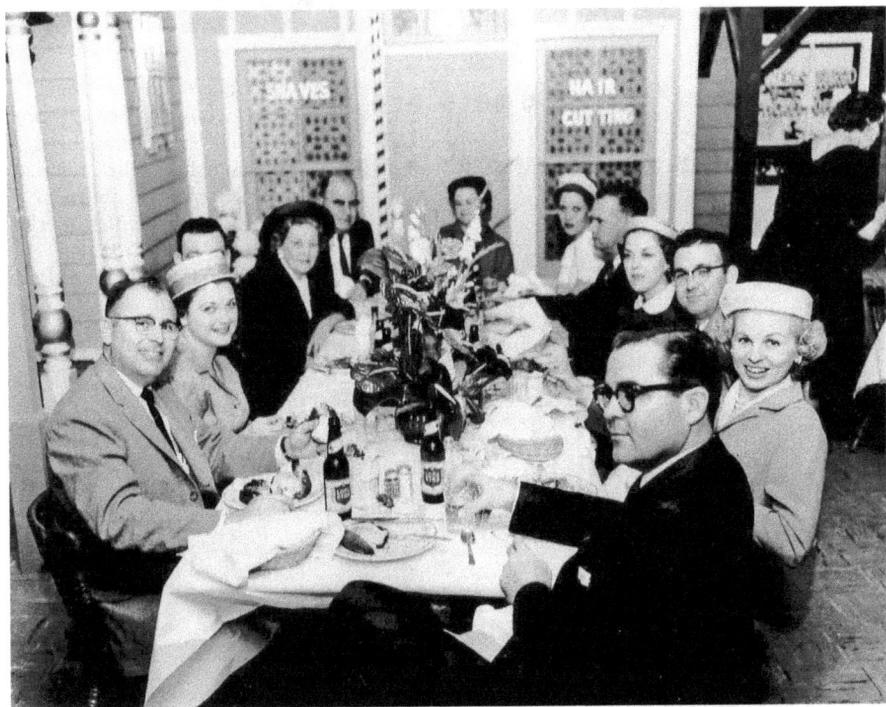

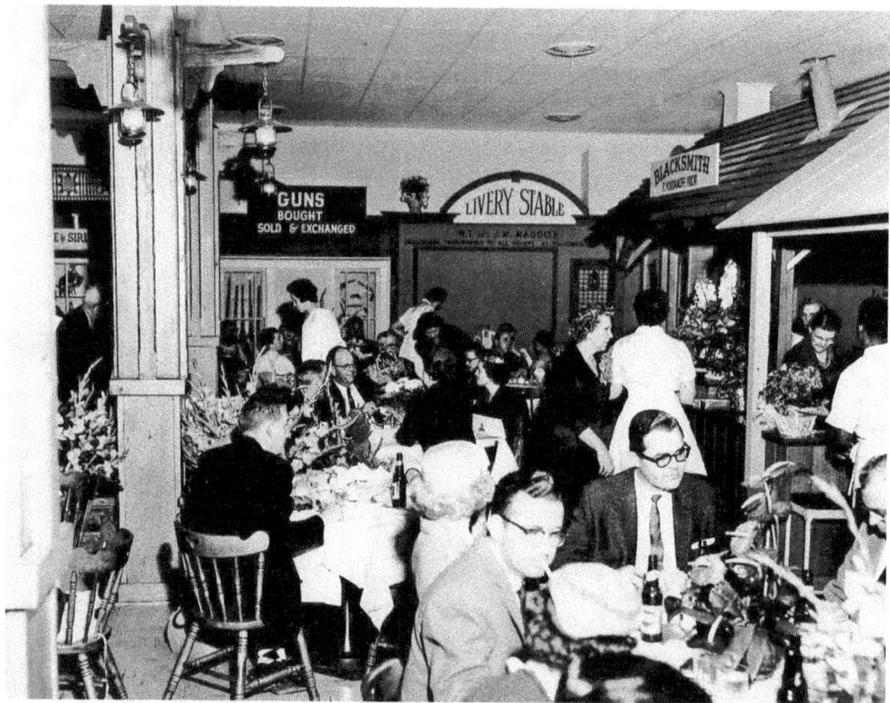

SADDLE & SIRLOIN INN

Above: Old storefronts, including a barbershop, blacksmith shop, bank, marshal's office, salon, saloon and hotel, were portrayed in the colorful new dining room of Theo's Saddle & Sirloin Inn. *Joe Riscky*.

Left: Theo's Saddle & Sirloin Inn menu. *Dalton Hoffman*.

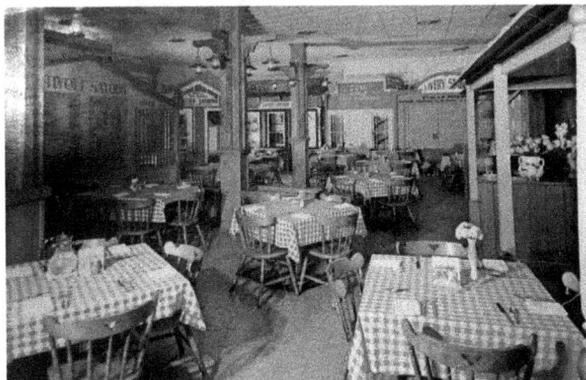

Left: The Theo's Saddle & Sirloin Inn menu included calf fries—the testicles of a young bull. Today, many popular Fort Worth restaurants still carry the item. *Dalton Hoffman*.

Right: Theo's Saddle & Sirloin Inn postcard. *Dalton Hoffman*.

1959 as Theo's Saddle & Sirloin Inn, completely rebuilt and decorated with Western scenes designed by a legit Disneyland architect, Harvey T. Gillet. Old storefronts of the 1860s and 1870s, including a barbershop, blacksmith shop, bank, marshal's office, salon, saloon and hotel, were portrayed in the colorful new dining room.

"This was in response to the Jesse Roach and Cattlemen's effort, and the Fort Worth effort, to build a western village in the Stockyards area," said Kennedy in his history lecture.

Theo's remained popular for steaks, which came in multiple varieties of rare, including "warm rare" and "cold rare," as well as Polish kraut soup and fresh apple ice cream made with Red Delicious apples and apple pie spices. When Yordanoff died in 1975, his daughters Wanda and Helen took over operations, keeping calf fries as a specialty on the menu.

"We don't marinate, soak, or tenderize them, but we do use batter," Wanda said to the *Fort Worth Star-Telegram* in 1983. "That's the way Daddy always did it, and that's the way we still do it."

Saddle & Sirloin Inn finally closed in 1985, but the Disney-inspired display still exists in the space today, now occupied by Riscky's Steakhouse, which opened in 1993.

And calf fries are still on the menu.

2
CAFETERIAS AND CAFÉS

It was reported that the first cafeteria ads around the early twentieth century boasted self-service and food that could be seen, along with the appeal of not having to leave a tip. These selling points helped spur a cafeteria explosion across the country, especially in the southern United States. Some say that the Industrial Revolution helped ignite the cafeteria's growth. Bringing a lunch box to work became less prevalent; cafeterias provided endless options of visually appealing home-cooked favorites, from pot roast and meatloaf to turkey with dressing and icebox pies, all for a low price. Cafeterias were also open to women, unlike some turn-of-the-century saloons. But the rise of fast-food dining by the 1960s caused the cafeteria to decline in popularity, although some in Fort Worth listed here managed to see success through the 1980s.

While cafeterias drew crowds through the mid-twentieth century, so did several Fort Worth landmark cafés. These were laid-back eateries with quality cooking where the waitresses knew not only your name but also exactly what you wanted to eat and how you wanted it done. Some routine patrons frequented their favorite café multiple times a day. The camaraderie between regulars and employees was just as pleasing as the food itself.

COLONIAL CAFETERIA

Perhaps the most popular Fort Worth cafeteria chain was Colonial Cafeteria, established in 1940 by C.W. Horan and his sons Charles, William and Robert, along with his son-in-law B.L. Gunter. But it was Ann Morgan Sprinkle, a dietician and home economics major, who designed the menus.

"Her personal supervision of the foods to be served each day is an assurance that a well balanced meal, tastefully seasoned, may be chosen with speed and a minimum effort on the part of the diner," said an advertorial in the *Fort Worth Star-Telegram* in 1951.

Popular menu items included liver and onions, fried chicken, roast beef, hot rolls, fried okra, banana pudding and coconut pie.

The first location was at 3062 University Drive. It moved to Berry Street and Sandage Avenue in 1955 upon the opening of a brand-new, 10,000-square-foot, one-story structure, of which Colonial occupied 7,600 square feet.

Charles Horan Jr. told the *Fort Worth Star-Telegram* in 1954 that the new location, which seated 260 and was more than one thousand square feet bigger than the original, would allow service to more patrons. Customers would also have access to the three-hundred-car parking lot at nearby Cox's Department Store.

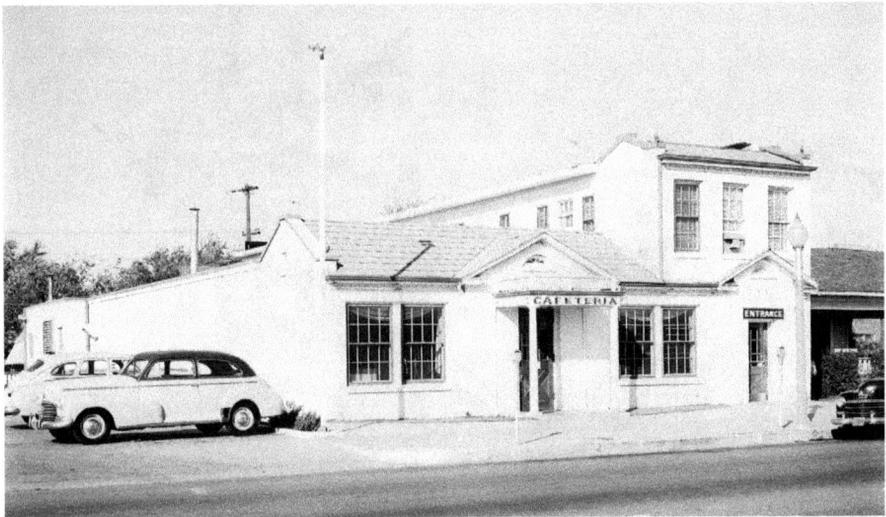

Colonial Cafeteria at 3062 South University Drive in 1949. *W.D. Smith Photography Collection, Special Collections, the University of Texas at Arlington Libraries, Arlington, Texas.*

Employees at Colonial Cafeteria at 3062 South University Drive, 1949. *W.D. Smith Photography Collection, Special Collections, the University of Texas at Arlington Libraries, Arlington, Texas.*

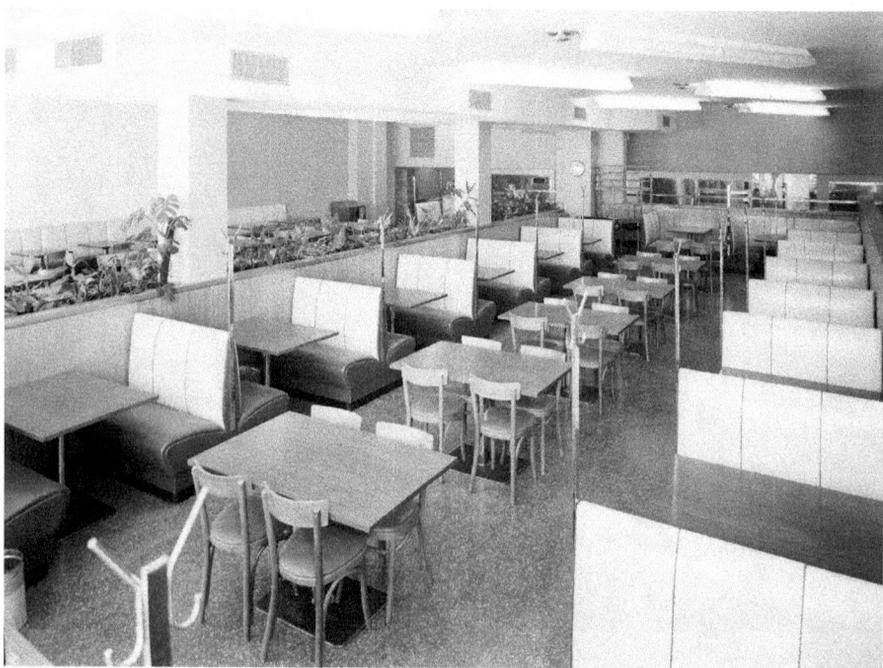

Colonial Cafeteria dining room, 1951. *W.D. Smith Photography Collection, Special Collections, the University of Texas at Arlington Libraries, Arlington, Texas.*

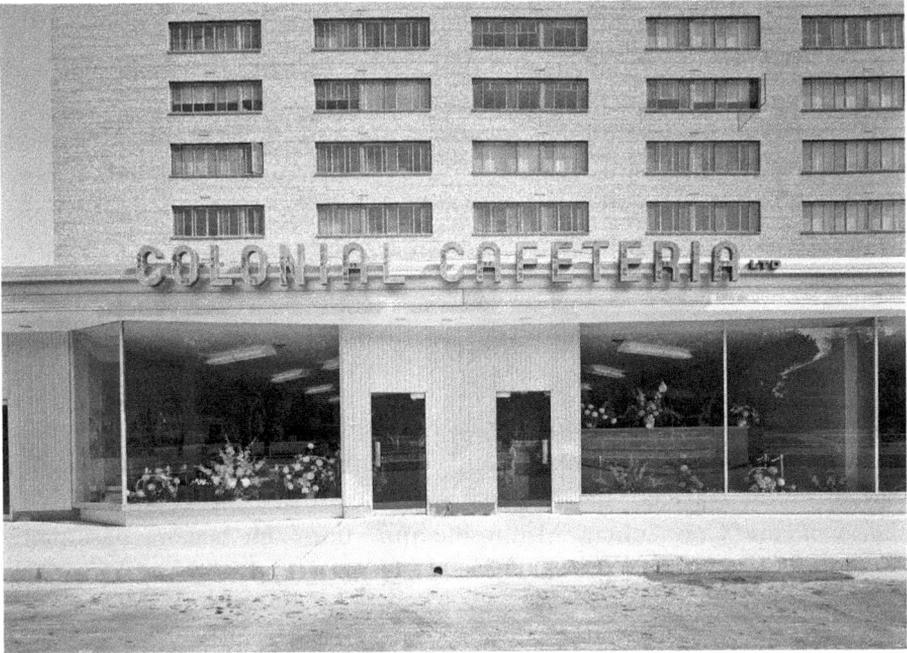

Colonial Cafeteria at 1520 Pennsylvania Avenue, 1951. *W.D. Smith Photography Collection, Special Collections, the University of Texas at Arlington Libraries, Arlington, Texas.*

"My grandparents on my father's side, Harry and Sadie Miller, would get there about 3:30 p.m. and sit in their car and read the afternoon *Star-Telegram* and wait for them to open at 4:00 p.m.," said Jack Miller, owner of Haltom's Jewelers in Fort Worth. "Then they would fight with the other old people to see who could be first in line. They had to get home to watch the 5:00 p.m. *Huntley-Brinkley Report* on NBC."

Colonial Cafeteria locations eventually spread to Pennsylvania Avenue in the Westchester House high-rise apartments, Trail Lake Drive and Haltom City. The Pennsylvania Avenue location was inspired by southern hospitality both in decor and cuisine. Outfitted in pastel green and adorned with a wall mural of a Louisiana plantation, the location featured the latest in modern cooking equipment, including heated storage cabinets for plates.

In 1976, Colonial Cafeteria acquired Jetton's, another cafeteria with a focus on barbecue. The brand became Colonial-Jetton's, Inc., and included multiple cafeteria locations. But all Colonial-Jetton's establishments were sold just a few years later.

In 1988, with strong competition from larger cafeteria chains like Wyatt's, Luby's and Furr's, Colonial opened yet another location at Interstate 20 and Bryant Irvin Road in the Cityview shopping center.

In 1991, an explosion caused by a natural-gas leak in the basement destroyed the Pennsylvania Avenue location, which never reopened. As fast-food and corporate restaurants became more popular, all Colonial locations eventually closed.

JETTON'S

Donning his signature cowboy hat and armed with cooking utensils, red-and-white checkered tablecloths and an authentic ranch chuck wagon, Walter Jetton traveled the country catering Texas barbecue as far as California and Connecticut, Minnesota and Miami. He became nationally known as Fort Worth's premier barbecue guru, even dubbed President Lyndon B. Johnson's favorite chef.

"Walter Jetton and Lyndon Johnson are regarded as the two Texans who made barbecue famous. When Amon Carter had guests out to the Shady Oak ranch, he served them steaks. Barbecue was not considered the talk of Texas like it is today," said *Fort Worth Star-Telegram* food columnist Bud Kennedy in a speech for the Fort Worth Library about the city's iconic restaurants. "Jetton didn't just put Fort Worth on the map; he put Texas on the map."

Jetton operated the meat department of the Trimble Grocery Store on Cooper Street in the late 1930s before eventually buying the store and establishing his catering operation. He attracted national attention in 1951 when he was invited to cater the Texas State Society's annual picnic in Washington. He arrived in his Texas best, with kitschy Western regalia for himself and his crew, along with props to match.

Shortly after the event, the *Saturday Evening Post* ran a story naming Jetton the "Kingpin of the Barbecue Men." *Time, Life, Newsweek* and other publications followed with more publicity, keeping him in the spotlight. Johnson frequently called on him to cater events at his ranch. Jetton called himself the "King of Texas Barbecue."

He eventually launched a fleet of trucks to cater across the nation and opened a restaurant and pantry at Seventh and West Terrell Avenues, where, in 1961, chopped beef sandwiches were advertised as selling for seven for a dollar.

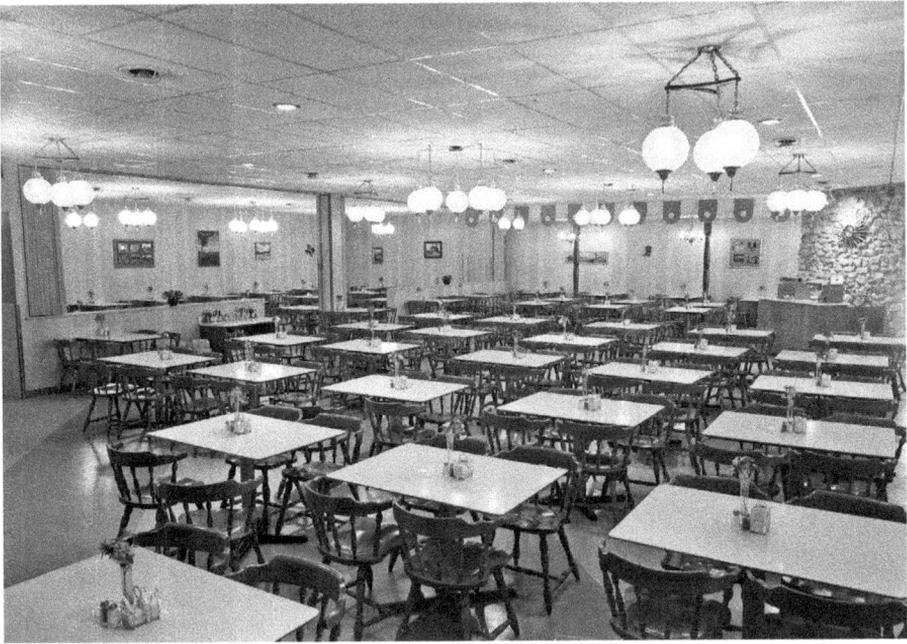

Walter Jetton's cafeteria at Seventh Avenue and West Terrell, 1962. *W.D. Smith Photography Collection, Special Collections, the University of Texas at Arlington Libraries, Arlington, Texas.*

In 1963, he was booked to cater a dinner in Austin to welcome President John F. Kennedy, but Kennedy sadly never made it out of Dallas. A month later, Jetton catered barbecue for three hundred people at President Johnson's first state dinner, which was held in the Texas Hill Country. The menu reportedly included pinto beans, barbecue spareribs, coleslaw and fried apricot pies, along with hot coffee and "plenty of beer." The affair was forever labeled the "Sparerib Summit."

"When Lyndon Johnson was elected and started digging pits in the White House lawn and having Walter Jetton come barbecue a whole side of beef for all the international media, or had people down at the ranch for barbecues, that's when the world started taking note," Bud Kennedy said.

In 1967, Jetton opened a flashy, expansive new cafeteria at 1700 Rogers Road with much fanfare. Ads promised self-service counters "heavily laden with Walter's wonderful foods." At the charcoal counter, steaks were broiled to order. Poultry, seafood and seasoned vegetables were also offered—more than two hundred items total.

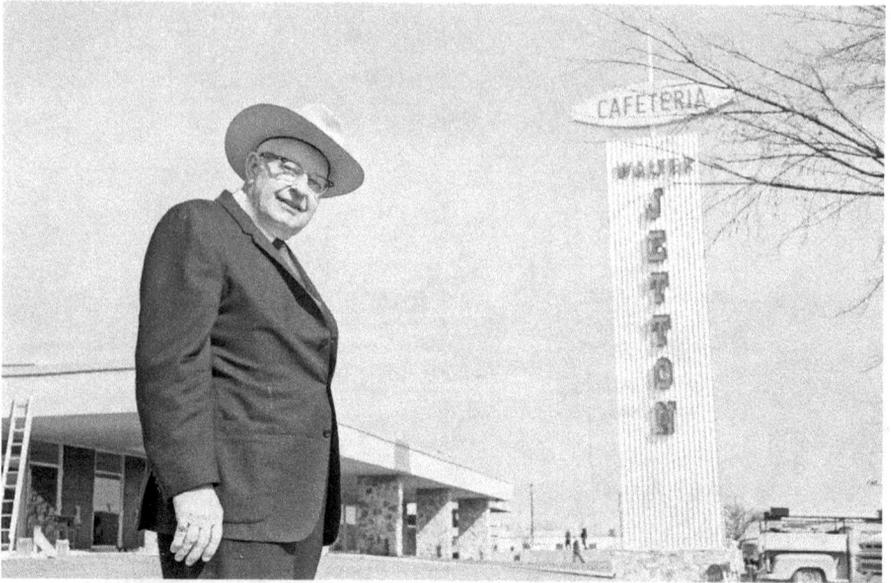

Walter Jetton stands in front of his new cafeteria at 1700 Rogers Road, 1967. *Fort Worth Star-Telegram Collection, Special Collections, the University of Texas at Arlington Libraries, Arlington, Texas.*

"Jetton's 'no-line' cafeterias add new enjoyment to dining out," one ad proclaimed. "The check for a family of four is usually only around $5."

The image of a chuck wagon always made appearances throughout Jetton's ad campaigns, to remind customers of his world-famous barbecue.

"Although he [didn't have] the first or the oldest barbecue restaurant, his role in popularizing barbecue in the '60s is recognized in all of the history books. When you look at famous pitmasters, Jetton may have been the first famous pitmaster who was written about in New York and Paris for his famous barbecue," Kennedy said. "He would take a side of beef and it was cooked over coals, not in an enclosed pit."

Barbecue enthusiasts looking for a taste similar to Jetton's charcoal-cooked barbecue might find it at Cooper's Old Time Pit Bar-B-Que in the Fort Worth Stockyards, Kennedy said. Based in Llano, Texas, the premier barbecue joint cooks its meat over open fire.

When Jetton died in 1968 at age sixty-one due to a heart condition, Lady Bird Johnson wired Jetton's widow sympathies from herself and the president.

According to the *Fort Worth Star-Telegram*, the wire read, "The President and I were deeply saddened to learn of Walter's death. He was a kind

and dear friend and we share your grief. We send you and your family our understanding and sympathy."

Jetton's was eventually sold to Buddies Foods, which in turn sold to competitor Colonial Cafeteria in 1976.

"Today, the Jetton name rings familiar to few aside from presidential or barbecue historians and some Fort Worth residents with fond memories of his restaurant," wrote *Texas Monthly* barbecue editor Daniel Vaughn in his 2015 profile of Jetton's rise to barbecue fame. "Jetton may have given himself the title 'King of Barbecue,' but for a few decades he certainly deserved it."

PICCADILLY CAFETERIA

First opened in 1932 in Baton Rouge, Louisiana, Piccadilly Cafeteria opened its downtown Fort Worth location in 1954 at 904 Houston Street. While the home-style eatery was a prominent chain with multiple locations across the South (and is still in existence today), its comfort food held a special place in the hearts (and stomachs) of many Fort Worth diners for more than two decades. Some regulars ate there every single day.

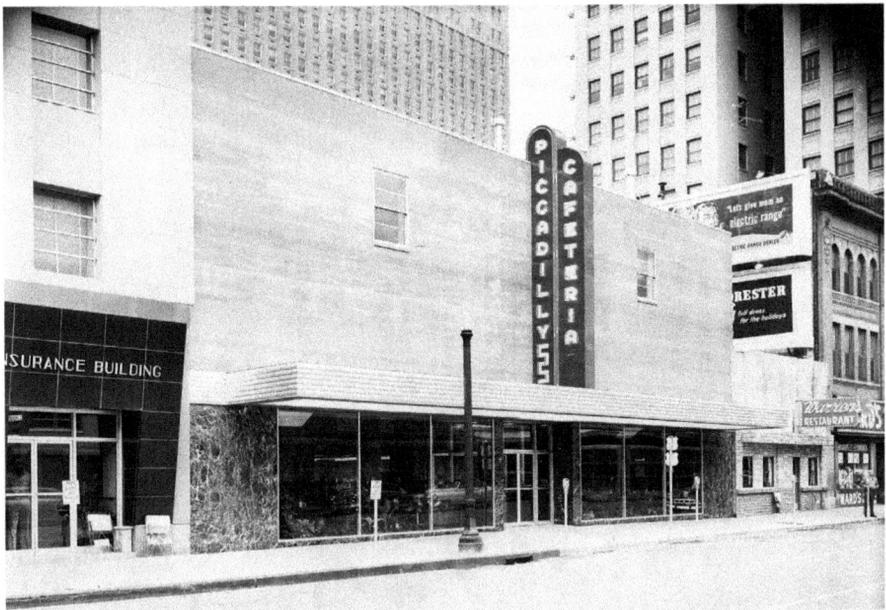

Piccadilly Cafeteria at its opening at 904 Houston Street, 1954. *W.D. Smith Photography Collection, Special Collections, the University of Texas at Arlington Libraries, Arlington, Texas.*

"Where am I going to find biscuits and gravy like these?" Shedrick Little asked a *Fort Worth Star-Telegram* reporter on November 18, 1977, the day the restaurant closed its doors. "Not only will they take me all the way to noon, but these biscuits, well, they put you right back at home. The taste is what I mean."

The biscuit maker was James Jordan, who claimed to have baked one hundred pounds of biscuits a day at the restaurant from when it opened to its very last day in business. Wearing pants caked with white flour and with a rolling pin in hand, he told the *Fort Worth Star-Telegram* that customers always asked him for the recipe, but he would never divulge.

"Besides, when I make my biscuits, I make them in 32-pound lots," he said. "It would be kinda hard to give someone that recipe."

With green granite pillars, multiple service lines and two levels of seating, the restaurant would fill early for breakfast, which started at 6:00 a.m. Crowds would return in droves at lunch. Daily specials included chopped beef steak with cornbread dressing and turnip greens, braised beef and macaroni with black-eyed peas and carrot and raisin salad, and on Fridays,

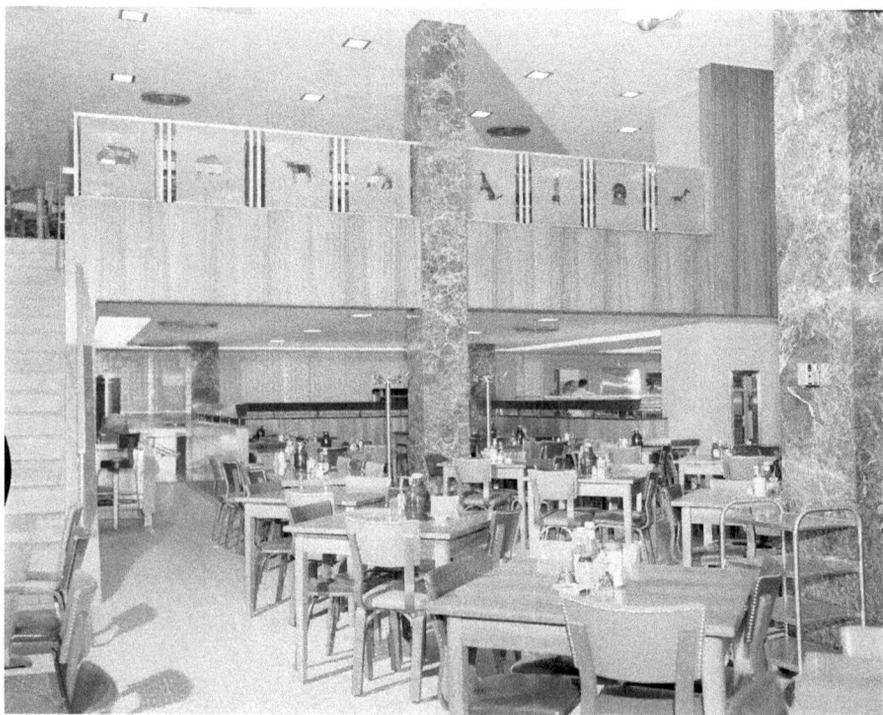

Piccadilly Cafeteria, 1954. *W.D. Smith Photography Collection, Special Collections, the University of Texas at Arlington Libraries, Arlington, Texas.*

Piccadilly Cafeteria advertisements. Left ad from 1954. Right ad from 1971. Fort Worth Star-Telegram.

Piccadilly Cafeteria was previously the home of Carter's Cafeteria. Advertisement, 1935. *From the* Fort Worth Star-Telegram.

fried fish with creamed carrots and shoestring potatoes. The menu changed weekly. In 1971, "Piccadilly platters," which included a choice of iced tea, coffee or punch, were ninety-five cents plus tax.

Piccadilly wasn't the first cafeteria to occupy the space. Carter's Cafeteria, originally opened by Georgia Rollins Carter in the basement of the Fine Arts Building at Seventh and Houston Streets in 1924, moved to the location in 1935 and then eventually to Main Street once Piccadilly took over.

Two businessmen named Chester Smith and Mike Langston purchased the Piccadilly—the very same day it closed—with the intention of remodeling it, retaining staff and reopening as the Pic with the same hours and the same menu. If they succeeded, the reincarnated version was very short-lived.

WAYSIDE INN

Many details regarding the Wayside Inn in downtown Fort Worth seemed to have "gone by the wayside," so to speak.

There was little reported in the *Fort Worth Star-Telegram* about the spacious café located at 509–511 Main Street, which historic postcards show as the epitome of 1930s-style restaurant interior design: checkered tile flooring, retro barstools that lined a long bar, four-tops and booth seating and art deco–inspired street-side signage. Geometric patterns and bold colors were prominent.

One exterior view shows two entrances just steps from each other, one with the word "café" over the door and the other designated as "grill." Window signage promoted chicken dinners, sizzling steaks and Blatz Milwaukee beer.

Ads in the mid-1930s invited customers to come to the Wayside for the "finest food and drinks," as well as for the air conditioning.

According to an inscription printed on the back of one of the restaurant's colorful menus, the Wayside Inn was established in 1925 by Vaughn Osborn. The Wayside had a "nationwide reputation for excellent food," the menu touted.

Regarding the food, there was a great deal of it. Menus were lengthy and listed dozens and dozens of items, everything from southern flounder with lemon butter sauce and grilled lamb chops with currant jelly to ham-and-cheese omelets and hot tamales. One 1944 dinner special offered fresh Gulf shrimp with select Maryland oysters and cold sliced kosher ox tongue.

Osborn moved to Fort Worth from Ohio in the 1920s and was employed as a cook at the Wayside, which was then just a small café. He bought the

WAYSIDE INN, 509-11 MAIN, FORT WORTH, TEXAS G-205

Wayside Inn ads in the mid-1930s invited customers to come for the "finest food and drinks," as well as for the air conditioning. *Dalton Hoffman.*

Wayside Inn represented the epitome of 1930s-style restaurant interior design: checkered tile flooring, retro barstools that lined a long bar, four-tops and booth seating and art deco–inspired signage. *Dalton Hoffman.*

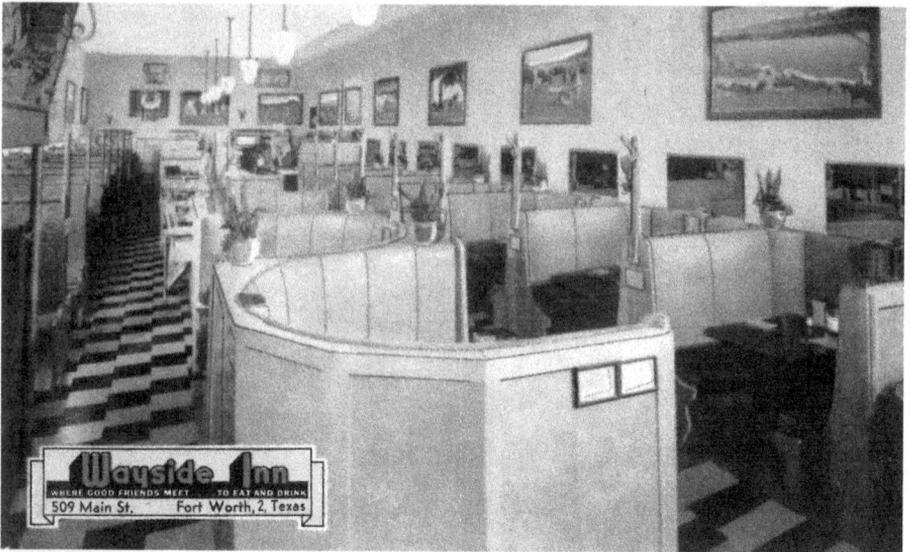

Wayside Inn was established in 1925 by Ohio native Vaughn Osborn. *Dalton Hoffman*.

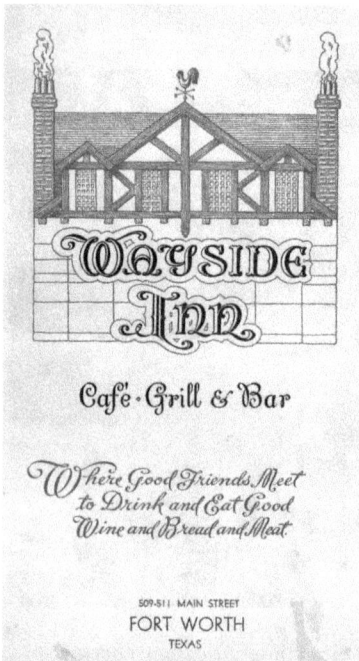

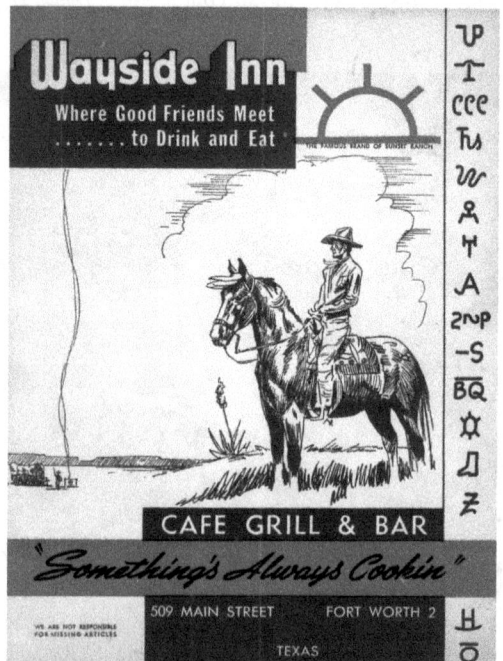

Left: The Wayside Inn was promoted as a place "where good friends meet to drink and eat." *Dalton Hoffman*.

Right: The Wayside Inn closed by the late 1940s. *Dalton Hoffman*.

Wayside Inn menu items ranged from flounder to ham-and-cheese omelets. *Dalton Hoffman.*

restaurant and expanded it twice, adding an upstairs cocktail room. The Wayside made headlines in 1936 after charges of violating the state liquor law were filed after a raid. Osborn and his team were charged with possessing liquor exceeding 14 percent alcoholic content. The restaurant had a permit to sell only beer and wine.

Vaughn Osborn died of a heart attack at age forty in 1939, just hours after donating blood for his critically ill uncle. After Osborn's death, his wife, Vila Christina Osborn, took control of the busy restaurant and tavern. She married William Walker Stevens in 1941. It was reported that he disrupted its management and caused employee discontent. The future of the Wayside was doomed with their divorce in 1947. After an ugly divorce settlement, the restaurant was reported to head to the auction block later that year. A dance studio moved into the space by 1950.

STEVE'S AND FINLEY'S CAFETERIA

In black-and-white tile embedded in the sidewalk just outside the triangle-shaped building at 4700 Camp Bowie Boulevard, the name "Steve's" serves as a permanent reminder of one of Fort Worth's earliest restaurateurs.

Steve was Steve Murrin Sr., a bona fide Fort Worth cowboy with extensive ranch hand experience who, after returning from World War I in 1919, opened Steve's Chili Parlor downtown.

"When he got back from World War I, the cattle business wasn't doing well because they cancelled all of the government contracts," said his son Steve Murrin Jr. "He found a little spot on Seventh Street, near the corner of Seventh and Main. It was long and narrow, only about twelve-foot wide. I think it was in an alley. There wasn't even room to sit down. It was a stand-up thing."

Murrin Sr. sold hot bowls of chili from 1919 until 1927. He learned how to prepare the meal in large batches as a cook during cattle gatherings at ranches. Chili was what he knew, his son said.

Eventually setting his sights on a larger space, Murrin bought the slice of pie-shaped property at 4700 Camp Bowie Boulevard in 1927. The space, now expanded, is where Lucile's Stateside Bistro sits today.

"It started as a drive-in with carhops," Murrin Jr. said. "It only had the narrow part of the back room. The other half was added later."

Murrin Jr. didn't come around until 1938, but he recalled the early beginnings of his "daddy's" restaurant with great detail as if he was there.

"He had one really good year; 1928 was a very prosperous year in Fort Worth. In 1929, there was the Great Depression. When that happened, nobody had any money. People quit eating out because they couldn't afford it. The banks were going broke. You couldn't get money out. What saved him was his specialty: ham sandwiches. They were fifteen cents a sandwich."

Murrin Sr. eventually became the largest buyer of Armour brand ham, because his sandwiches and their cheap price tag were a huge hit for folks on the road. Steve's Triangle, as the restaurant was most commonly referred to, sat at a perfect stopping point for those headed west to California. Dozens of customers came in daily, many hauling used cars to make money.

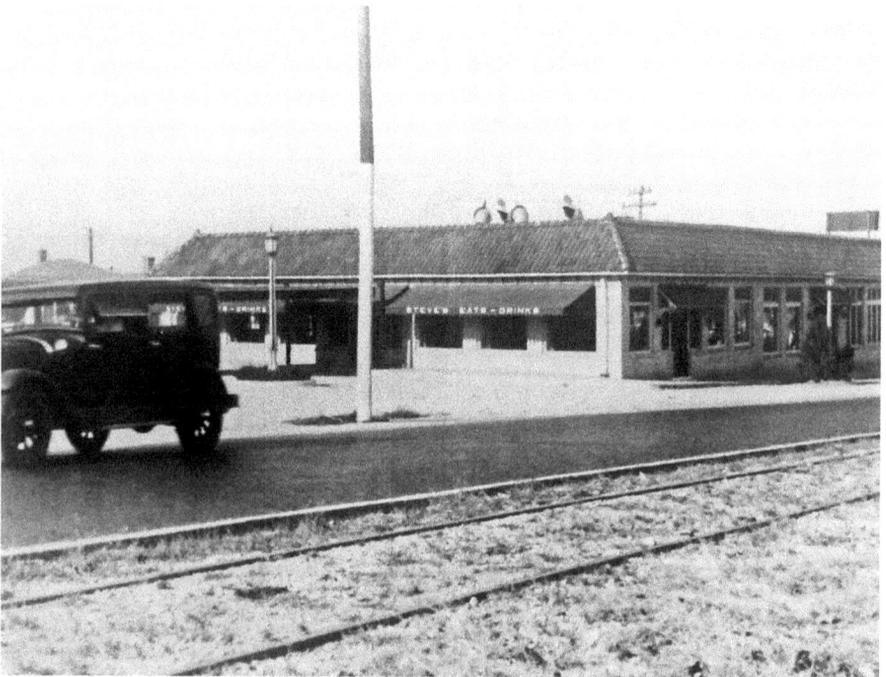

Steve's, circa late 1920s. *Bob McLean.*

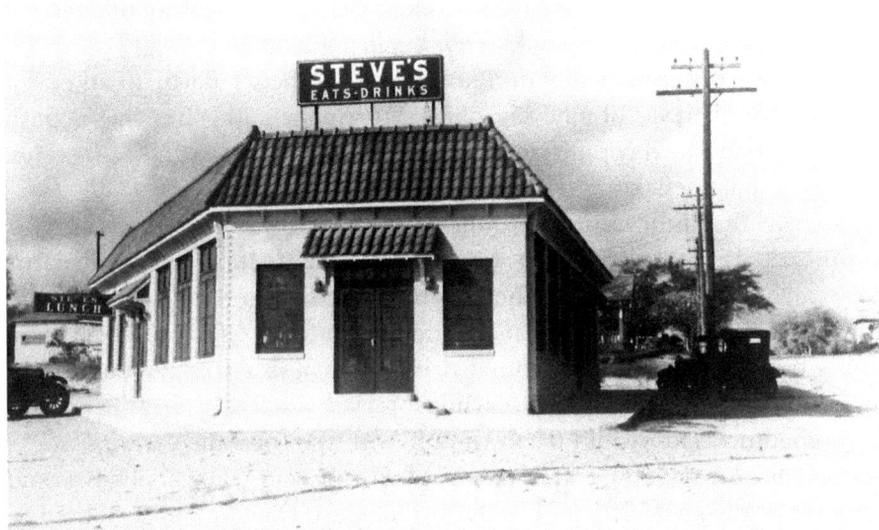

Steve's, circa late 1920s. *Bob McLean.*

"There was a market for used cars in California. They would pay you to drive used cars there and give you lunch money," Murrin Jr. said. "They'd come in and get big sacks of ham sandwiches. He was right on the end of Fort Worth. They were just paving Camp Bowie with red brick, and people would stop there before they'd take off down Highway 80, all the way to California through El Paso, New Mexico and Arizona. There'd be a dozen of them all caravanning out there. They'd come in and buy about ten ham sandwiches apiece. That saved him during the Depression years."

The café prospered. A dining room with a marble floor was later added, and the kitchen was expanded. Steve's drew crowds and became known as one of Fort Worth's top dining destinations. But with the local fame came a few unwelcome guests.

"In the '30s, everybody thought they were a gangster, like Humphrey Bogart. They were always holding people up," Murrin Jr. said. "In the kitchen, my dad had a little cabinet right above the door where he always kept a couple of pistols and a sawed-off shotgun. People would always come in and size up the joint and see about holding him up. He'd just stick one of those pistols in his belt and carry it around the restaurant. They wound up

holding up the place across the street instead—the Rockyfeller. They held it up three or four times, but they never tried to hold Steve's up."

If someone looking even remotely dubious walked in, employees at the cash register knew to push the buzzer under the counter that sounded in the kitchen, where Murrin Sr. would often be slicing ham.

"He'd like to slice it really thin and pile it on; better flavor to add a lot of thin slices instead of one big one," Murrin Jr. said. "But they'd push that button and he'd coming running out of the kitchen with that shotgun. They'd do it if they thought someone was suspicious."

Murrin Sr. didn't mess around when it came to protecting his restaurant. Perhaps it was his years spent as a cowboy followed by his departure for World War I. When World War II started, he lost his entire crew of carhops—all of them male and away at war. Many of them were young boxers. He, like many other drive-in owners across the country at the time, started hiring female carhops.

"Sometimes, kids would try to run off with the trays the carhops would put on your car window and not pay," Murrin Jr. said. "His honchos would hang out at the restaurant and tell him. Then he'd run out and get a hold of them. All of the cars back then had running boards on the side. They'd jump on a car and yell, 'Follow that car!'"

Murrin Jr. said the thieves were often yanked out of their car, and the tray would be retrieved before they were let go. "But they'd always rough them up a little bit for stealing their trays," he said. "It was kind of the law of west Camp Bowie."

By the early 1940s, Murrin Sr. had sold his restaurant business but kept the building, which is still owned by the family today. Businesses that came and went include Renfro's Triangle Cafe, Duncan's Cafeteria (which also had a location on Eighth Avenue) and, most notably, Finley's Cafeteria, another Fort Worth mainstay for several decades. Ray Finley married the daughter of Rema Duncan and managed the location before eventually taking over.

"He reduced down the menu and had just enough for what he thought the crowd would be, and when he ran out, he ran out," Murrin Jr. said of Finley. "He'd get there really early for all of the fresh food and produce that would come in. He'd get the first meal on the stove and then he'd go to Colonial Country Club and play a round of golf every morning. He'd come back right after lunch and see how they did. Then he'd plan the evening meal and turn it over to a lady he had that was real efficient and oversaw everything. He'd go back and play a half round of golf and then play bridge,

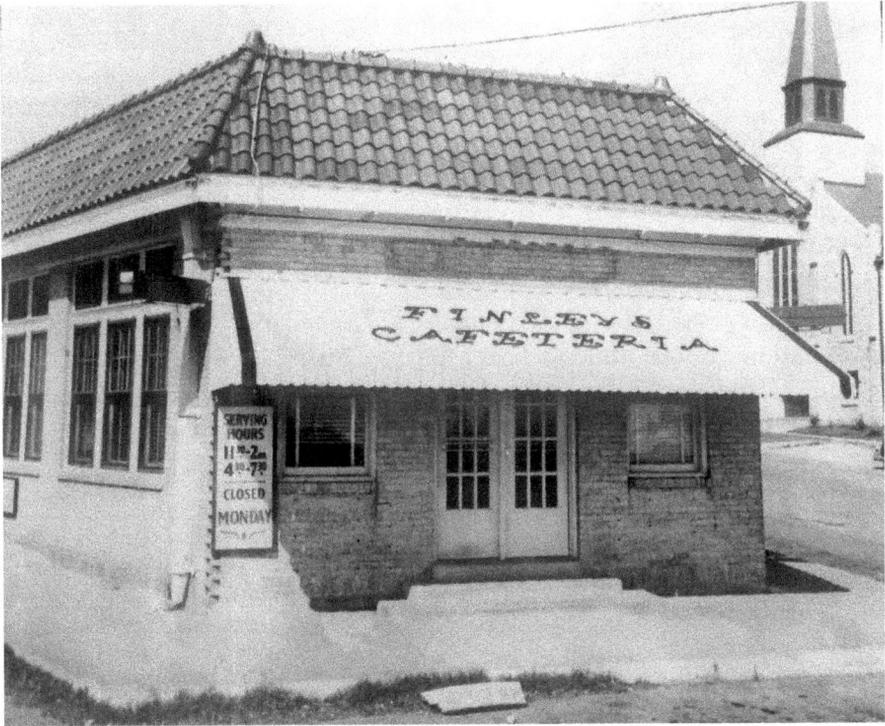

Finley's Cafeteria opened in the Steve's space by the late 1940s. *Bob McLean.*

or whatever they played over there at Colonial. He usually didn't come back in the evening."

With his extremely organized yet not overbearing management style, Finley experienced great success for three decades. The cafeteria was known for home cooking. According to a 1976 *Fort Worth Star-Telegram* article, Finley's buffet line always included liver and onions on Tuesday and corned beef and cabbage on Thursday. Then there were the cakes and pies.

"He had really good pies," Murrin Jr. recalled. "He had a pie lady who actually carried over from my daddy's restaurant." That pie lady was Ella Lawrence. Thanks to her and her baking skills, customers mourned Finley's even more after its closure.

"Please, please help me," wrote a reader to *Fort Worth Star-Telegram* columnist Ed Brice in 1979. "Ever since the closing of Finley's Cafeteria on Camp Bowie, I have been sinking into the uncontrollable pains of withdrawal from deprivation of their pineapple cake. Could you find out what path the dessert cook has taken? Where in Fort Worth can I find the good fairy who

used to make the pineapple cake? I'll buy the recipe. I'll slip through the night incognito to her back door. I'll pick it up in a plain brown wrapper on the corner of Seventh and Main at midnight. I'll swap my second born son."

Brice informed the desperate reader that Lawrence was working at the Black-eyed Pea, which took over the Finley's space in 1979. Unfortunately, the cake was not on the chain restaurant's menu; however, Lawrence reportedly occasionally prepped desserts for longtime Finley's patrons who asked.

The Black-eyed Pea operated until 1992, when Bob McLean leased the space and began restoration to open Lucile's Stateside Bistro in 1993. The restaurant was named for his mother and still operates today. In the lobby area near the hostess stand, several black-and-white photos of both Steve's and Finley's hang on the wall, commemorating the building's rich restaurant history in Fort Worth.

TOPSY'S CAFÉ

On October 25, 2016, Fort Worth motorists along White Settlement Road might have been startled to see oversized cargo of massive proportions. Loaded onto the flatbed of a monstrous Mack truck was an entire restaurant—not restaurant kitchen equipment and dining room furnishings, but an eighty-ton restaurant dug up out of the ground and moved in its entirety from one location to another, miles away.

"Is it easier to build it from scratch? Yeah, but it's not the same," Milo Ramirez told an NBC 5 reporter that day.

The building was home to his popular Fort Worth taqueria Salsa Limon, opened in a historic Streamline Moderne structure that was built in 1947 and housed many landmark restaurants throughout its storied past. Ramirez could have let the building be bulldozed to the ground after he was told by owners of the 929 University Drive address that the taqueria had to go to make way for larger, mixed-use development.

Instead, he worked with the Historic and Cultural Landmarks Commission to preserve the building and make the move, which was estimated to cost between $30,000 and $66,000. Fort Worth mover H.D. Snow & Son House Moving, Inc., handled the project. Streets had to be cleared, power lines had to be checked and H.D. Snow himself had to be in charge.

"It darn near made me start cussing," Snow told NBC 5. "I've never done that, but I started, got pretty close."

Streamline Moderne is a later type of art deco architecture that emphasized curves, long horizontal lines and even some nautical elements. The aluminum façade features horizontal banding around the windows, rounded building corners and ribbed metal panels.

"Although the small aluminum building is a modest representation of the aerodynamically styled chrome-and-glass diners of the thirties and forties, it occupies a unique place in Fort Worth cultural and architectural history because of its salvage aluminum construction and Streamline design," wrote author Judith Singer Cohen in her book *Cowtown Moderne: Art Deco Architecture of Fort Worth, Texas*.

Its first tenant was Topsy's Café, opened by W. Jack Allen in 1947 and operated with his wife, Vivian. Allen learned to cook in the navy during World War II and became famous for his "Topsyburger." According to his obituary, Allen was thought to have been "cranky with his cooking," but his wife said, "In reality he was a perfectionist."

The restaurant's success allowed the couple to close for a month at a time to travel around the world to Europe, South America, the Caribbean and Hawaii. Allen was also a huge sports fan. He sponsored many Little

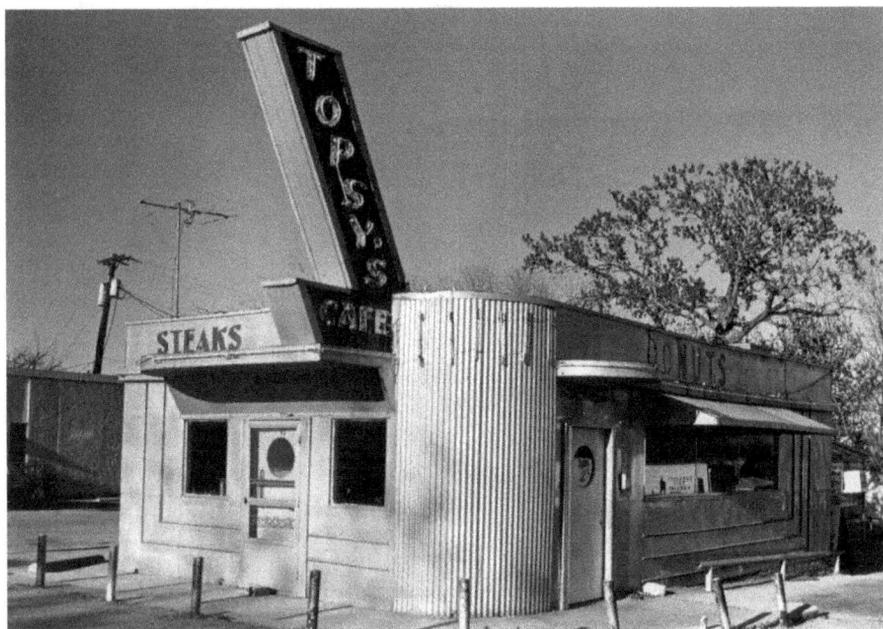

Topsy's Café opened in 1947 in a Streamline Moderne aluminum building on University Drive. The building, now occupied by Salsa Limon, was moved to West Fort Worth in 2016 to avoid demolition. *Judith S. Cohen.*

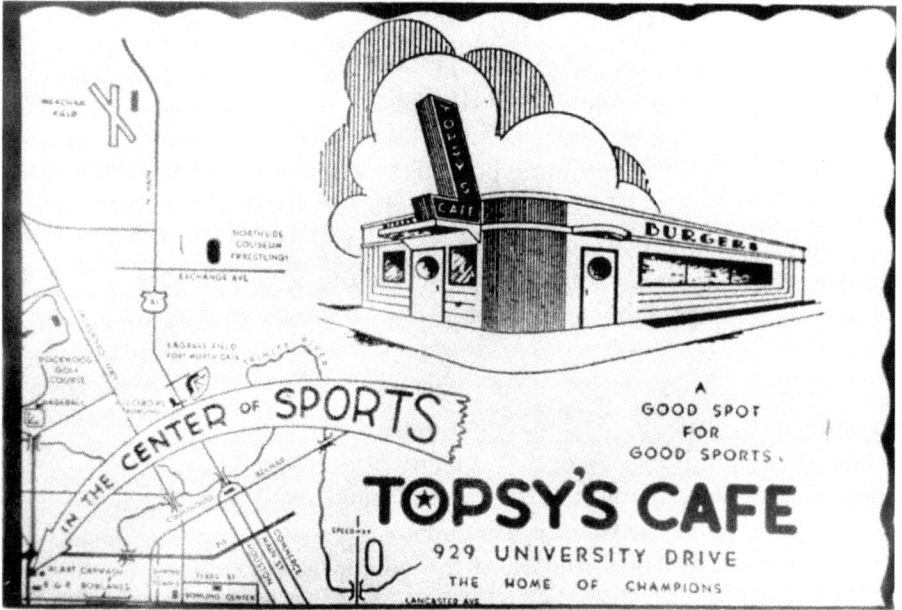

Topsy's Café was owned by W. Jack Allen, a local sports enthusiast. *Judith S. Cohen.*

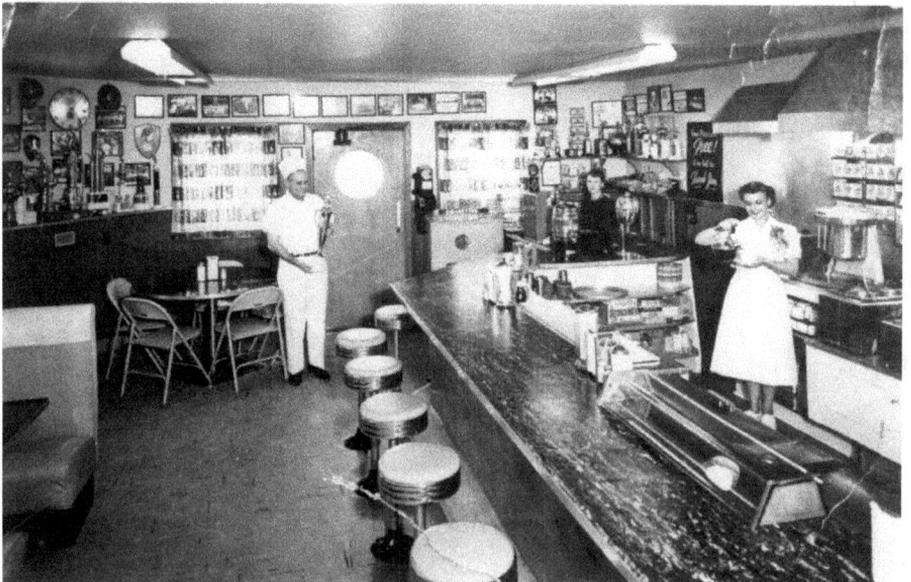

W. Jack Allen holds a trophy inside his Topsy's Café. *Judith S. Cohen.*

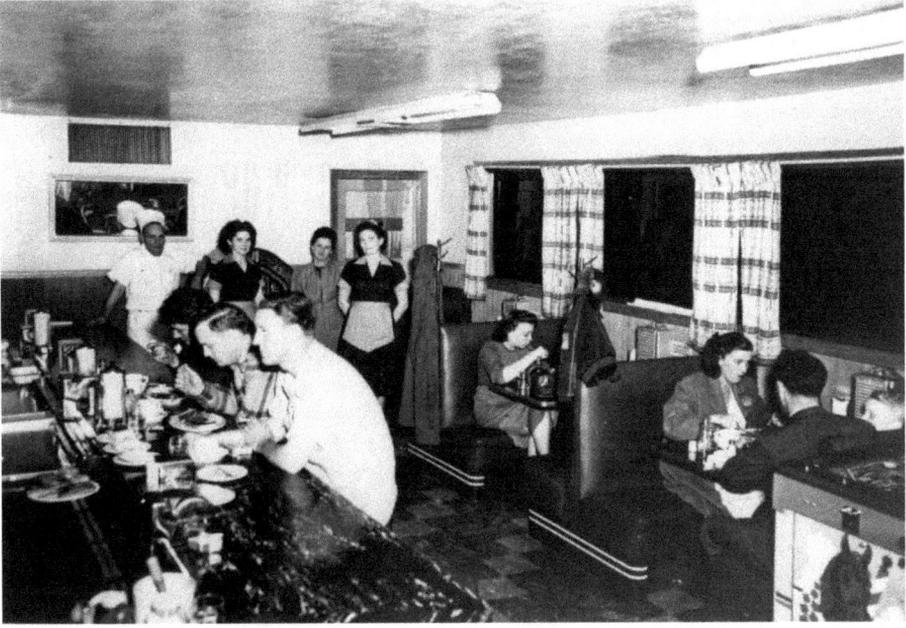

Topsy's Café interior. *Judith S. Cohen.*

League baseball, basketball and hockey teams. A 1954 ad for Topsy's had the slogan, "A good spot for good sports." Historic photos of Topsy's interior show several trophies along with framed team photos on the wall. Customers bellied up to the bar for hearty home cooking or sat in vinyl booths featuring individual tabletop jukeboxes and stands to hang letterman jackets and trench coats.

Allen died in 1972; his wife ran the business for two more years until the space went up for lease in 1974. Restaurants that followed include J&J's Oyster Bar (which still operates down the street), Rush Street and a Quiznos. Salsa Limon moved the building to 5012 White Settlement Road to be a part of Fort Worth's River District development.

"It keeps that whole mysticism," Ramirez said of preserving the building. "We need to keep that kind of quality to us."

3
DRIVE-INS AND DOO-WOP

ecause automobiles were less common before World War I, roadside
restaurants were few and far between. In the 1920s, the number of
vehicles in America grew dramatically thanks to the development of
assembly line mass production.

The Pig Stand, a Dallas-based chain established in 1921, is widely credited
as the first drive-in restaurant, or at least the first that launched the concept
of carhops.

By the 1950s, drive-in restaurants became a nationwide phenomenon,
serving as the perfect venue for young adults to show off their prized rides.
Drive-ins were the place to be seen—magnets for revving engines, cheap
dates and big egos.

LONE STAR DRIVE-IN

"Depending on where you lived, that's where you would drive your car and
hang out. That was the culture of drive-ins," says Pam Benson, daughter
of successful Fort Worth restaurateur and Lone Star Drive-In owner Dave
Benson. "If you went to Paschal High School, you'd hang out at this
particular drive-in, and if you went to the North Side High School, you'd
hang out at another drive-in."

Benson opened his first Lone Star in 1949 on Berry Street at Interstate 35,
having previously dabbled in the nightclub business.

Lone Star Drive-In opened its first location at Interstate 35 and Berry Street in 1949.
Pam Benson.

"There was nothing but rabbits out there," he told the *Fort Worth Star-Telegram.*

But the public soon became accustomed to the drive-in concept, and more locations followed, including one at Seventh Street and Penn Street and one on Camp Bowie Boulevard. Competition included Carlson's Drive-Inn on South University Drive and Clover Drive-In, which had locations on East Rosedale Avenue and Jacksboro Highway.

Drive-ins were home to the iconic carhop waitresses, with their flashy outfits in shiny satin, signature pillbox hats and even roller skates. The young ladies were considered glamorous, and the position was highly coveted, Pam said.

Martha Williams, Benson's longtime secretary, told the *Fort Worth Star-Telegram* that he hired the first black carhops and waitresses, before civil rights marches.

Lone Star menu items included everything from breakfast combo plates for seventy-five cents and homemade chili for forty-five cents to filet mignon with potatoes, a salad and rolls for two dollars. Sandwiches were fifty cents or less, and the Lone Star's popular onion rings were thirty-five cents an order.

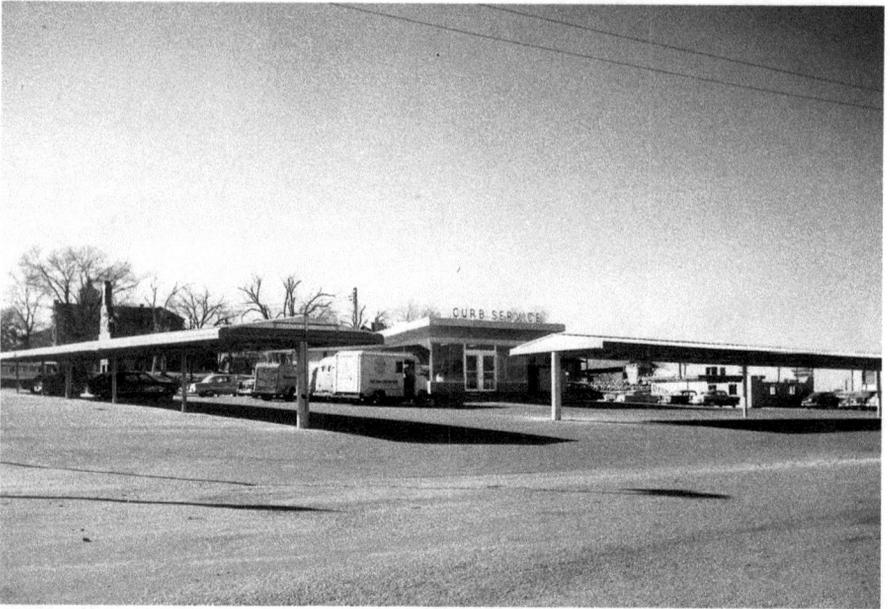

Lone Star Drive-In at Seventh and Penn Streets. *Pam Benson.*

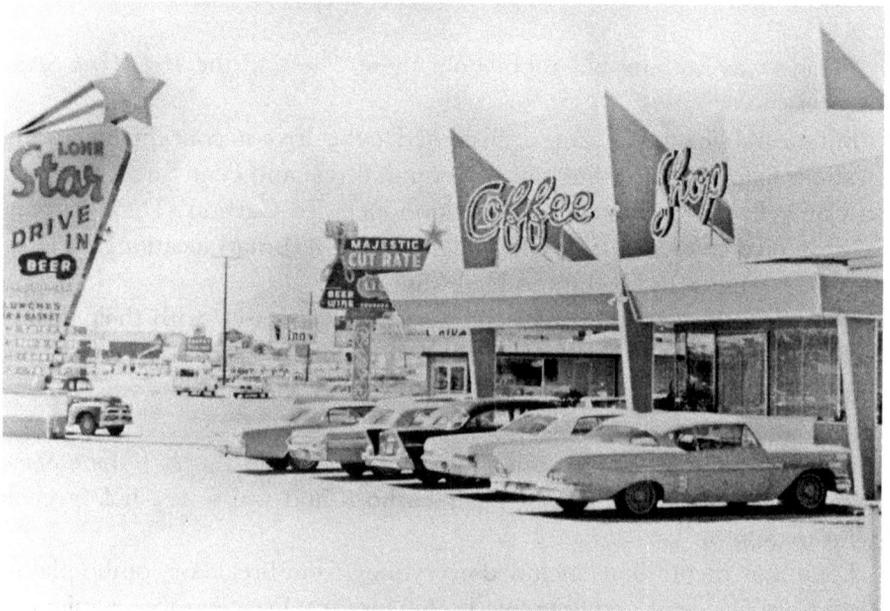

Lone Star Drive-In on Camp Bowie Boulevard, early 1960s. *Pam Benson.*

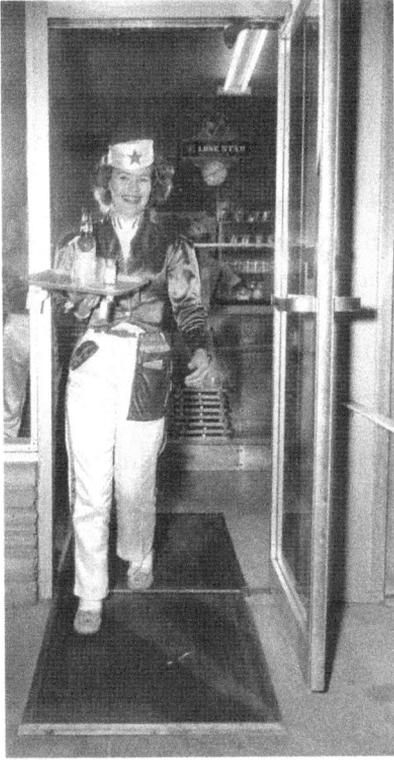

Left: Carhops were considered glamorous, and the position was highly coveted, says Pam Benson, daughter of Dave Benson, who established Lone Star Drive-In. *Pam Benson*.

Below: Updated Lone Star Drive-In at Interstate 35 and Berry Street. *Pam Benson*.

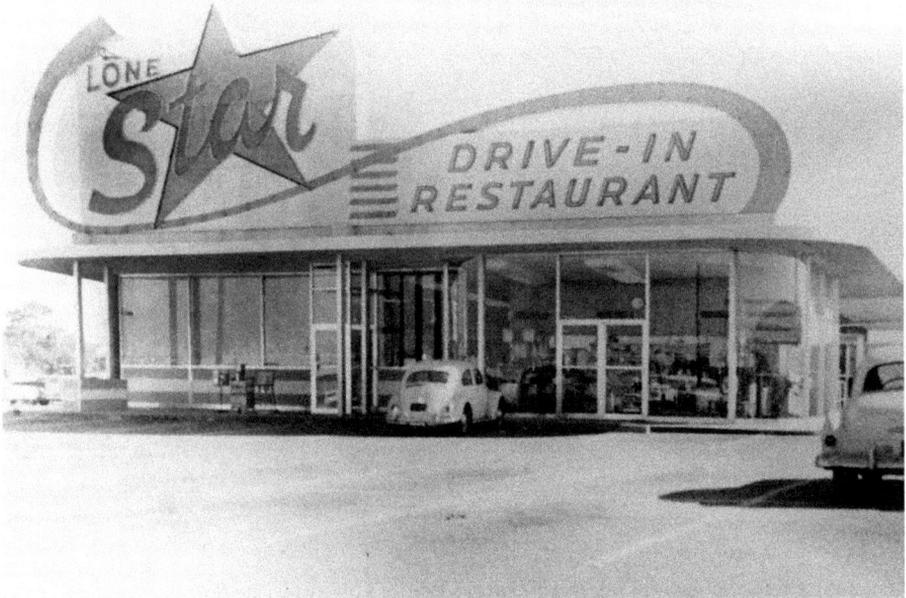

"Onion rings were very big at the Lone Star," said Pam, a restaurateur herself and owner of Japanese Palace on Camp Bowie West Boulevard. She worked frequently at the Berry Street location as a child.

"Baskets came on little trays and were put on your car window," she said. "When I was a kid, there was a soda jerk, and he would make the milkshakes and the malts. The carhops would pick up those drinks and carry them out. The way I remember on Berry Street, we had a dining room where you'd walk in and sit down, and there was always a counter and booths and a jukebox."

Pam got excited, she said, when the "jukebox man" would visit to exchange old records for newer ones. That meant she would receive a bundle of 45s at home.

All Lone Star Drive-Ins were open twenty-four hours, meaning patrons varied from early-morning breakfast diners, workingmen on lunch breaks, beer-guzzling car gang members and folks looking to sober up over a hefty chicken fried steak at 2:00 a.m., one of the Lone Star's busiest hours.

"On Friday and Saturdays is when all the gangs would come with their cars. That was a big deal," said Pam. "People were crazy; drinking beer and driving cars round and round. Things changed. We wanted to be safe."

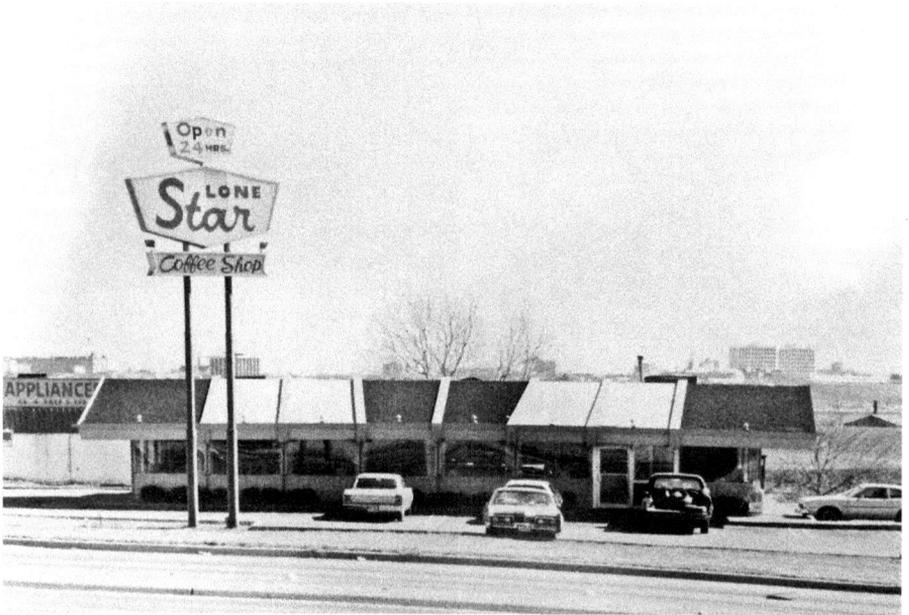

Lone Star Coffee Shop was built in 1969 on Jacksboro Highway. *Pam Benson.*

By the 1960s, Lone Star Drive-Ins started morphing into Lone Star Coffee Shops. Customers were already familiar with Benson's stellar coffee and dining room service thanks to his Ol' South Pancake House on University Drive, opened in 1963. It still operates today under the ownership of Rex Benson, Pam's younger brother.

"Everything has an era," Pam said. "When it's time to change, you have to change to keep up with the times."

CARLSON'S DRIVE-INN

Home of the beloved Bakon Burger—a charbroiled bacon cheeseburger topped with a secret, Thousand Island–like sauce—Carlson's Drive-Inn at 1660 South University Drive held its own as a hot spot for bobby socks, fast cars, backseat make-out sessions and an occasional parking lot rumble or two.

Opened in 1952 by Carl Carlson Jr., who served in the army during World War II, the drive-in restaurant was like a home away from home for Paschal High School and Texas Christian University (TCU) students in the 1950s through early 1960s.

"I imagine there were 200 or 300 cars on the lot, if it was full," former carhop Lou Hitt told the *Fort Worth Star-Telegram* in 1981, just after Carlson's closed. "There were six carhops on the evening shift. We all got so we could take seven or eight trays out at once."

With white satin pants adorned with purple stripes down the leg (to match the colors of Paschal and TCU), the talented carhops served frosty mugs of root beer, cherry and vanilla sodas, malts and milkshakes, as well as beer to those who were old enough.

The drive-in routine for the fellows consisted of pulling in, circling around continuously in order to be seen (with rolled-up sleeves while flexing bicep muscles as hard as possible, perhaps against the ledge of a rolled-down car window) and finally choosing a spot before perhaps partaking in an engine-revving war with a neighboring vehicle or blaring a coded series of honks corresponding with a particular social club.

"When I was a teenager, my friends and I went to Carlson's on a regular basis, especially on weekends," said Mike Moncrief, who served as Fort Worth mayor from 2003 to 2011. "Saturday night was the big night, and every once in a while we would go during a weeknight. As I recall, my go-to dish was the 'Bakon Burger.' It was grilled, had cheese, lettuce, tomatoes, onions on a sesame seed bun, of course dripping with grease."

Moncrief described Carlson's as a Fort Worth institution.

"It was 'meet you at Carlson's' or 'see you tonight at Carlson's,'" he said. "If you went there on a Saturday night and sat there long enough, you'd see everybody you knew. It was a 'see and be-seen' environment. The carhops were friendly, the food was good, the fries were good and management let us congregate until it became a problem, which is what happened."

By 1962, Carlson put out barricades to deter the endless circling of vehicles, which began to intimidate patrons. "Management finally did away with congregating at the restaurant. You had to be eating or ordering if you wanted to stay there," Moncrief said.

Former Fort Worth police officer Tommy Tucker, who spent thirty-five years with the department, patrolled the area in the 1960s through the early '70s. But it was his colleague, Captain Lawrence Wood, who worked the lot at Carlson's virtually full time.

"He was a very big man, and the kids recognized he had the strength to do what he said he was going to do," Tucker recalled. "If he said something, he'd never back down from it. His word was written in stone. He was real liked by the kids, and the kids understood if he said 'no,' he meant business."

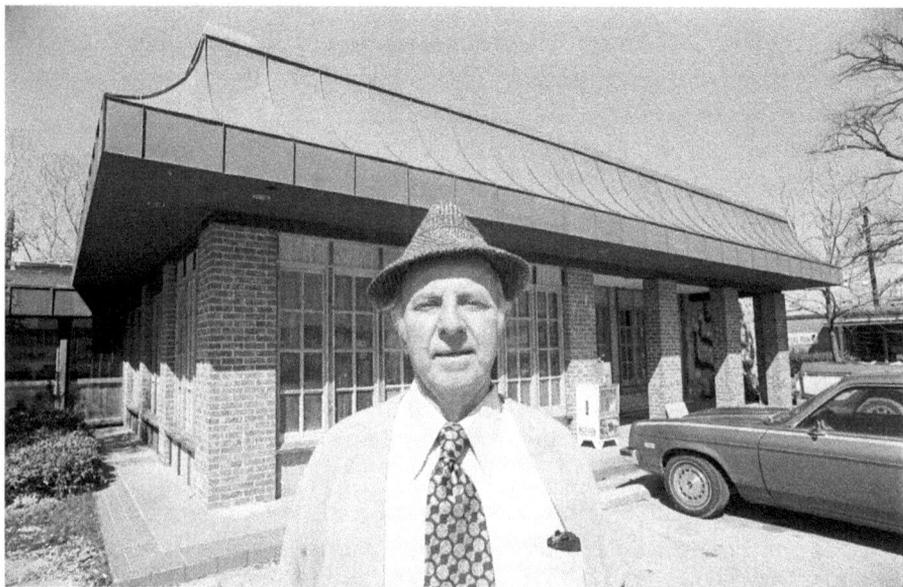

Carl Carlson Jr. stands in front of Carlson's Drive-Inn at 1660 University Drive in 1981, the year after the restaurant closed. *Fort Worth Star-Telegram Collection, Special Collections, the University of Texas at Arlington Libraries, Arlington, Texas.*

Most of the carhops were fond of the kids who frequented Carlson's, Tucker said, as long as they didn't interfere with their job or disrupt their rhythm. "It was very open, very busy," he recalled. "The carhops were really on the go the whole time they'd be on a shift."

But they still had time to often serve as matchmakers and confidants, occasionally making a quick loan to a student on a date who came up short on cash. They were reported as being the friendliest carhops in Texas.

Tucker said he wasn't a Bakon Burger man himself (he preferred a plain patty on a dry bun), but he was very much in the minority.

On Friday, April 6, 1990, ten years after Carlson's closed and two years after Carlson died, his wife, Georgia, brought the Bakon Burger back to life for one evening.

Fort Worth Star-Telegram food writer Bud Kennedy reported that more than twelve hundred baby boomers gathered on the Paschal High School lawn while Georgia stirred up her original sauce and charbroiled a rendition of the beloved bacon cheeseburger to raise money for the school's sports program.

"Carlson's was the Mel's Diner of a Fort Worth generation, a doo-wop drive-in on University Drive where teenagers lived, fought and loved," Kennedy wrote. Since the departure of Carlson's from the Fort Worth restaurant scene, he's continually asked where one can get a good Bakon Burger.

"It was perfect," he wrote of the burgers that Friday night. "The Bakon Burgers had the same smoky taste, with dressing oozing onto paper wrappers stamped with 'Carlson's Drive-Inn.'"

In 1971, Carl Carlson converted his hip hangout into a restaurant sans the drive-in service for its last decade in business, attracting a more middle-aged clientele. The drive-in era had passed, but some of those middle-aged customers were former Carlson's Drive-Inn regulars themselves.

DINERS, DIVES AND COWTOWN COOKING

Whether referred to as greasy spoons, holes in the wall, diners or dives, Fort Worth was full of them in the mid-twentieth century. These eateries might not have had the most glamorous of settings, with weathered walls, timeworn tables and well-seasoned grills, but they drew crowds for their consistency and delicious dishes to match. Chili, chicken fried steak, burgers and a little Tex-Mex—practically the four food groups of Fort Worth—were well represented at these restaurants, along with hot, strong coffee, crucial to any American dive.

FAMOUS HAMBURGERS

If there was one thing former patrons of Famous Hamburgers remember about the downtown Fort Worth dive, it technically wasn't the burgers themselves.

It was the smell of…grilled onions and sizzling grease.

"The windows used to open out, and it caused the entire downtown to smell so good!" recalled Fort Worth mayor Betsy Price. "It made us all hungry."

With a classic striped awning, lots of windows and signage that shouted, "Hamburgers, Cheeseburgers, Coney Island & Fish," the street-corner stand at Main and First Streets stood for sixty-five years as an iconic destination for greasy grub. Burgers were simple, grilled on a flat top with

chopped onions pressed into the patty, slathered with a bit of mustard, topped with cheese, if desired, then slapped between two buns and served hot. Famous was, of course, famous for its burgers but also for the battered and deep-fried codfish fillet sandwiches. It was also famous for longtime owner Nick "the Greek" Koutsoubos, a colorful character who was born for the business, it seems.

"I don't know when it was my father came here, but him and Gus had an ice cream business before they started this," he told the *Fort Worth Star-Telegram* in 1986, the year Famous Hamburgers flipped its last patty and closed. Nick's father was George Koutsoubos, and Gus was Gus Voites, his godfather. "When this place first opened, it was called G&G Hamburgers, for Gus and George. The first building here was wooden. Later, George left and went to California. My father took it all for himself. Papa died in '34."

Family members ran the eatery before Nick dropped out of ninth grade at North Side High School and took over. Famous drew crowds for its five-cent hamburgers in the 1930s and '40s. Six burgers were sold for a quarter. Back then, Nick said, the dive was surrounded by domino parlors, beer joints, cafés and a barbershop. Leonard Brothers department store was thriving, and downtown was bustling. He told the *Fort Worth Star-Telegram* that the era provided his fondest memories of the restaurant's years in business.

When the building's owner decided it was time to remodel and update health and safety standards, Famous Hamburgers was forced to close. The shabby stand had no phone, no air conditioning and no water heater—only a gas burner under the sink. Nick Koutsoubos's money box was a women's handbag purchased more than four decades prior, held together by string and tape. There was also no sprinkler system in the case of a fire.

"These people talk about preservation...history....This place is a tradition," Koutsoubos told *Fort Worth Star-Telegram* reporter Christopher Evans just before closing, continuing that the building owner wanted to modernize the structure and rent to a newer business. "If I was going to stay in business, I'd want to keep the same image."

But Koutsoubos's image was forever commemorated on May 24, 1986, when the Tarrant County Commissioners Court declared the day "Nick Koutsoubos Day" in honor of his decades running Famous Hamburgers, which was almost just as often referred to as "Nick's Place."

RICHELIEU GRILL

"Chili, stew and ham hocks and lima beans. Those were the three things that kept us afloat all those years," J.C. Fletcher told the *Fort Worth Star-Telegram* in 1991. He owned the Richelieu Grill, a century-old downtown landmark, from 1949 to 1987.

According to newspaper reports, the Richelieu was established sometime between 1885 and 1895 by two brothers who named the eatery after the Dallas businessman who loaned them the money to open it. The upstairs offered hotel guest rooms with rates around two dollars a day at the turn of the century, according to city directories. The hotel portion burned around 1930, eliminating the overnight accommodations.

Fletcher moved the restaurant from its original location at Fifteenth and Main Streets to Houston Street in the early 1960s. The popular dive landed in its final location in 1970 at Fourth and Main Streets.

Patrons who recall the Richelieu first and foremost remember the chili. The original chili recipe was apparently lost until Fletcher discovered it written on wallpaper near hidden stairs at the restaurant's original location. Longtime cook Theopolies James told the *Fort Worth Star-Telegram*

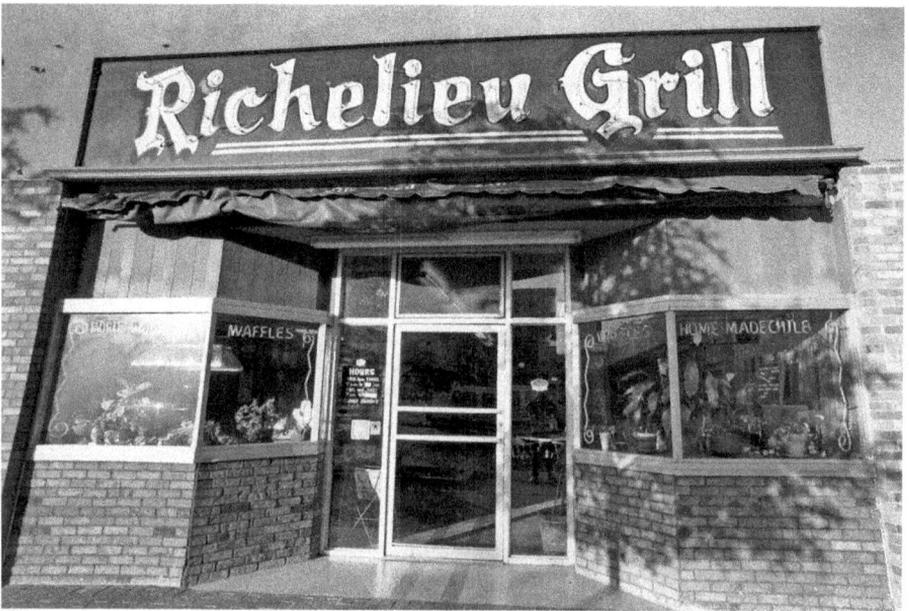

Richelieu Grill in 1985 at its final location at Fourth and Main Streets. *Photo by Craig Howell, www.fortworthyesterday.com.*

Richelieu Grill menu. *Dalton Hoffman.*

that key ingredients included three spices from Manila that made their way from the Philippines to the Richelieu kitchen via San Francisco. The recipe was never divulged.

Other menu standouts included chicken and dumplings, country fried ham with grits and chicken-fried steak.

James and Hisako Woolsey bought the restaurant in 1987, only to run into immediate challenges. James passed away shortly after the purchase. David Woolsey, a son of James, told the *Fort Worth Star-Telegram* that temporary closings due to interior problems, as well as decreased downtown traffic, caused cash flow to suffer, resulting in the historic eatery's closure in 1991.

Fuqua's Coffee Shop menu. *Dalton Hoffman.*

FUQUA'S COFFEE SHOP

Paris Coffee Shop gets all the credit as Fort Worth's landmark breakfast and lunchtime diner destination, and with good reason. Not much has changed since the historic café opened in 1926 at the corner of West Magnolia Avenue and Hemphill Street. But, just blocks away at Hemphill and Pennsylvania Avenue sat another longtime dive with "coffee shop" in the title.

Fuqua's Coffee Shop drew customers for decades for its two-egg omelets and eighty-five-cent plate lunch specials like stuffed peppers and roast beef with brown gravy, pimento cheese sandwiches with potato salad and, of course, quick refills of hot coffee. Opened as a meat market, grocery store and coffee shop in 1905 by L.O. Fuqua, the establishment remained a mainstay in Fort Worth for seventy-five years.

"We have the nation's finest U.S. choice cornfed beef" announced a 1960 Fuqua's ad in the *Fort Worth Star-Telegram* touting the meat market portion of the business. But it was breakfast and lunch dishes for which the Fuqua name became the most known.

"Homestyle breakfasts and lunches so tasty that 10 days is the longest Mrs. Fuqua has missed regular customers in 21 years," proclaimed *Texas Monthly* magazine in 1973. By that time, breakfast specials ran from $0.49 to $0.89 and lunch specials from $1.35 to $4.25.

When L.O. Fuqua died in 1963, his sons Jack and Oscar took over the business and kept it successful. Jack died in 1971, and Oscar took the reins, running the business with his wife, Frances.

"Pancakes are the strong suit here," wrote Doug Clarke in his 1980 *Fort Worth Star-Telegram* story on the city's best breakfasts. "They are never mealy and always served with melted butter. The service was rated as 'good and friendly with quick coffee refills.'"

J.C. Fletcher of the Richelieu Grill purchased the business and reopened it as a second location in late 1980. By 1983, the space had been revamped again as Annie's Old Kitchen, with Frances back at the cash register. But in 1984, the restaurant, complete with all its inventory, stainless steel equipment, ice machines and meat market equipment, was put up for public auction.

MASSEY'S

In 1978, the Texas House of Representatives passed a resolution declaring Massey's chicken-fried steak to be the greatest served in Cowtown, calling it a "classic Texas meal."

Charles "Herb" Massey Sr. opened his namesake eatery in 1947 at 1805 Eighth Avenue in a former drive-in. Crowds were substantial through the 1950s, but Massey's was at its peak in popularity from the 1960s through the mid-1980s.

Massey's son Charles Massey Jr. ran the location for about twenty-five years with his wife, Diane. He told the *Fort Worth Star-Telegram* that from 1978 to 1986, the nearly windowless diner served six thousand steaks a week, "just regular as clockwork."

It was during the restaurant's prime that Steve Massey, son of Charles Jr. and Diane, worked at the restaurant, first as a busboy while still a child, then as a waiter and, later, "vice-president in charge of nothing," he said.

"I started working there when I was twelve or thirteen. I started bussing

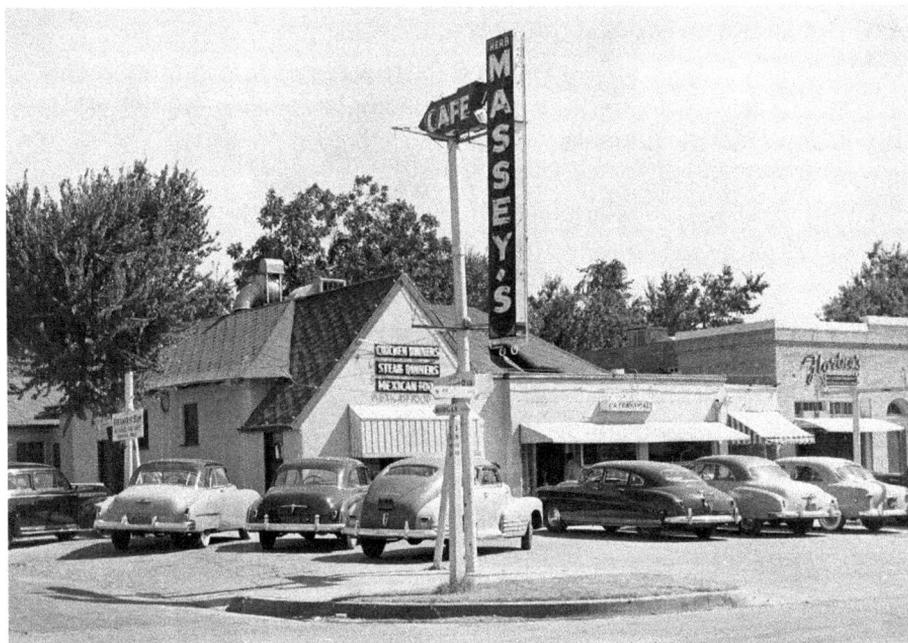

Massey's opened in 1947 at 1805 Eighth Avenue. *W.D. Smith Photography Collection, Special Collections, the University of Texas at Arlington Libraries, Arlington, Texas.*

tables and dishwashing," said Steve, who's now in the banking business. "When I was fifteen, I got to wait tables. I saved $12,000 my first summer waiting tables and paid cash for my first car. Mom and Dad gave me tremendous opportunities."

Regular customers frequented the restaurant, along with occasional local and national celebrities, like Reverend Jesse Jackson, U.S. House Speaker Jim Wright and professional golfers passing through Fort Worth for the PGA tournament at Colonial Country Club.

"When Colonial was going on, a group of golfers called for a private dining room," Steve said. "I actually talked to Tom Watson. They all came up there. I mean a group of twenty of them, even Greg Norman."

Steve said the lead singer of the band Alabama visited in the early 1980s, and a man who ran the Miss Texas pageant always brought in contestants. "That made me pretty happy when I was a kid," he said.

Every out-of-towner who visited Massey's came looking for one thing: chicken-fried steak.

What set that dish apart from others in town? "I think it was the batter and the homemade gravy you'd get on top," Steve said of the signature dish.

"And the biscuit. It was a really good combination. It was so easy to eat, you'd just use your fork. It wasn't tough. It was very top-quality meat."

Steve's father, Charles, who died in 2005, told the *Fort Worth Star-Telegram*, "If you don't buy the best you can buy, why, it's like trying to eat shoe leather, I guess."

A 1981 *D Magazine* review stated that while Massey's offered seafood and Mexican dishes, visiting for anything other than chicken-fried steak would be like going to the Grand Canyon to see the chipmunks. "Warning: Don't order the a la carte chicken-fried steak for lunch unless you have time for a siesta. The portions are huge, and it tastes too good to leave any behind," the review advised.

> *You won't be distracted by frills here. The menu advises that in the interest of conservation, water will be served upon request. There are no pepper shakers: tables are stocked with the original pepper cans. At lunchtime you get chicken-fried steak, salad, two vegetables, and homemade biscuits. The tender meat is cooked with a heavenly breading and topped with yellow creamed gravy, just the way they do it on that great spread beyond the sunset. The French fries are the kind you eat and then begrudge the lost space.*

Steve said multiple cooks in the kitchen knew the recipe for the dish, just in case one went on vacation or quit.

"Most of the employees were there for so long," Steve said. "There wasn't a tremendous amount of turnover, so it was pretty consistent."

But in 1996, the Massey family decided to close the business as a result of society's new health-conscious focus.

"There was the cholesterol kick and the fat kick and the fat grams, and that beat us over the head," Charles Jr. said, adding that business went downhill from then on.

The family put the business on the market in 1997. Folks from the Arlington Steak House carried on the Massey's name, but only until 2011. Regulars swear the place was never the same anyway. The building was finally bulldozed in 2014.

"I tell you what hurt us was when they first came out and started talking about fat in your diet," Diane said the day the building became a pile of brick and dust. "A lot of people were here eating chicken-fried steak every day and then they cut back."

When *Fort Worth Star-Telegram* food columnist Bud Kennedy is asked where one can find a chicken-fried steak today similar to that of Massey's lore, he recommends Star Café in the Stockyards or Ginger Brown's Old Tyme Restaurant & Bakery in Lake Worth, along with Reata and Billy's Oak Acres BBQ for more upscale renditions.

"There are not any restaurants now that sell six thousand chicken-fried steaks a week," Kennedy said. "Massey's didn't keep up with the times, and people's tastes change."

SAMMY'S RESTAURANT

"Van Cliburn comes here when he's in town," said Sammy Pantoja of his namesake North Side dive to the *Fort Worth Star-Telegram* in 1983. "And, when he can't make it, he sends his chauffeur over to take him back some food. He has a tremendously good appetite."

The internationally acclaimed pianist wasn't alone. Sammy's, opened in 1968, was widely known to attract a diverse crowd of characters and famished tourists, especially in the middle of the night. Located in a remodeled frame house at 300 West Central Avenue, just two blocks west of North Main Street, the restaurant opened at 5:00 p.m. and stayed open until 3:00 a.m. Tuesday through Thursday and all the way until 4:00 a.m. Friday and Saturday. This meant that everyone from hospital workers to folks leaving nearby bars and dance clubs filled the dining rooms at any given witching hour.

"We have all ranges coming in here," Pantoja told the paper. "We have babies at 3 a.m. The parents work night shifts and they pick up their children from the babysitter and eat here on their way home."

With dark red curtains, piped-in music and dim light provided by crystal fixtures, the restaurant was "pleasant, but not elegant," as described by *Fort Worth Star-Telegram* food critic Jack Bradley in 1976. Black felt paintings on the walls added character, but they weren't of museum caliber.

Waiters, who at one point were mainly Pantoja's young nephews, always wore black bow ties along with white shirts and black coats. The attire added a prim and proper element to the somewhat gaudy atmosphere, although patrons visited wearing anything they wanted. Tables often had several servers, each assisting with bringing salads or refilling drinks.

Pantoja's wife did all of the cooking, and the menu ran the gamut from Kansas City, fillet and T-bone steaks to enchilada dinners, fried shrimp and

Now Open — 5:00 P.M. 'til 2:00 A.M.

SAMMY'S RESTAURANT

Sammy C. Pantoja

Twenty-two years serving the people of Fort Worth with top quality steaks and Mexican food.
LOCATED AT THE CORNER OF ELLIS ST. AND N.W. 36TH
One Block West of North Main

Sammy's Restaurant advertisement, 1968. *From the* Fort Worth Star-Telegram.

chicken-fried steak. Steaks included a salad, baked potato, butter and rolls. Steaks also came with Sammy's very popular potato soup. Wine and beer were also sold, but Sammy's coffee was perhaps more popular than alcohol.

"I asked Sammy why his coffee is better than I make at home," wrote Bradley. "He does not use a special blend, but the secret is making small amounts as needed. It's always fresh."

The same was reported for his Mexican food, which wasn't prepared in large batches but rather in small portions and with a minimal amount of grease. And while the restaurant was technically open during the wee morning hours, breakfast wasn't served, with the exception of huevos rancheros. The menu remained mostly the same until 1984, when Pantoja added fajitas.

"I got outvoted," Pantoja told the *Fort Worth Star-Telegram.* "I didn't want them because it is so hard to get good meat, but my family wanted them. Now I bring in two girls for three hours every day to tenderize the meat for fajitas."

Pantoja passed away at age eighty-seven in 2015. He ran Sammy's for forty years, according to his obituary, which said he never met a stranger and frequently invited his customers to enter the restaurant through the kitchen door.

SURF, TURF AND SINGING WAITERS

W e're standing in the last outpost of steak in America," said *Fort Worth Star-Telegram* food columnist Bud Kennedy in a 2014 speech for the Fort Worth Library. "The Outback steak chain, a couple years ago, told me that Tarrant County, Texas, is the last place where they sell more steak than chicken or fish in their restaurants."

But Fort Worth steakhouses looked a lot different fifty to sixty years ago, with much more casual atmospheres compared to today's prime steakhouse standards. This era's premier Fort Worth steak destinations, such as Grace, Reata, Lonesome Dove Western Bistro and Bonnell's Fine Texas Cuisine, and successful chains like Del Frisco's Double Eagle Steak House and the Capital Grille, focus on fashioning stunning settings with stellar service almost as much as they focus on the cuts of beef. The combination works, as these venues are among the city's most popular restaurants, where reservations are always highly recommended.

As for seafood, options were few in Fort Worth until a man named Bill Martin came along and honed his shucking skills to sell raw oysters on the half shell in 1957. He created an empire of restaurants that spanned the country, but he eventually drowned in debt.

Italian food was also fairly new to Fort Worth by the 1950s, when many customers of the Italian Inn on East Lancaster Avenue thought pizza pies were actually desserts. The enclosed booths became highly sought after, and the waiters started singing. Soon, the restaurant became legendary.

THE FARMER'S DAUGHTER

On September 13, 1955, there were more than two dozen ads from owners of various businesses, including Vandervoort's Dairy, Ben E. Keith and C&H Cigar Company, in the morning edition of the *Fort Worth Star-Telegram* congratulating Jesse Roach on the grand opening of his new restaurant, the Farmer's Daughter. Roach, a lawyer who also owned a successful insurance company, had already built a strong reputation for high-quality steaks at his first restaurant, Cattlemen's Steak House, in the Fort Worth Stockyards, which opened in 1947 and still operates today.

Located at 1536 South University Drive, the Farmer's Daughter became known for its prime rib, charbroiled steaks, hot yeast rolls and themed dining rooms that bore names like the "Gay Nineties" and "The Traveling Salesman." Old San Francisco Barbary Coast–inspired decor included velvet wallpaper, red carpet, dark wood furniture and wrought-iron fixtures. A balcony overlooked the main dining area. The lounge, located in the

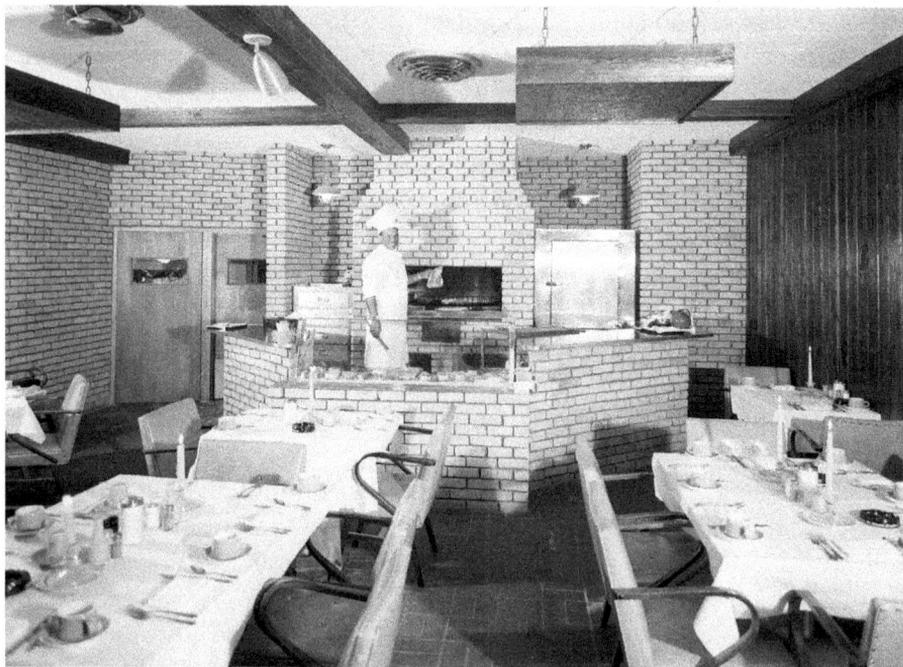

Steaks were prepared on charcoal grills in full display at the Farmer's Daughter restaurant, located at 1536 South University Drive and seen here in 1955. *W.D. Smith Photography Collection, Special Collections, the University of Texas at Arlington Libraries, Arlington, Texas.*

Left: The Farmer's Daughter opened in 1955 and became known for its prime rib, charbroiled steaks, hot yeast rolls and themed dining rooms. *Adam Jones*.

Middle: The Farmer's Daughter menu featured more than a dozen types of steaks. *Adam Jones*.

Right: Other popular items on the Farmer's Daughter menu included chicken-fried steak, trout amandine, lobster tail and gourmet ice cream in flavors like coconut, rum raisin, praline pecan and peppermint. *Adam Jones*.

basement, was popular for quintessential cocktails like gin and tonic, the Old Fashioned and bourbon and Coke.

Steaks were prepared on charcoal grills in full display in one of the main dining rooms, just like Cattlemen's Steak House today. Kingsford was the charcoal brand of choice, said David Phillips, a busboy turned kitchen backup who worked there as a teenager in the mid-1970s. Beef came from cattle fattened up on corn in Minnesota, he added.

"If you ordered a baked potato with your steak, the waitresses would fix it up for you tableside with cheese, bacon, sour cream and chives," Phillips said. "You would not fix your own baked potato."

Phillips was also in charge of preparing the prime rib cart, which was strategically placed by the entrance on Friday and Saturday nights to entice customers. Steam was created with vessels of water and hot coals to heat

the prime rib steaks, which were prepared rare, medium or well done. Sour cream and pure horseradish were combined to create an accompanying sauce, and Phillips would also display the restaurant's Yorkshire pudding.

The menu, which advertised "charcoal broiled, corn-fed steaks," featured more than a dozen types of steaks, including "ranch tartare" made from raw sirloin beef topped with a raw egg, chopped onions and green peppers. Other popular items included chicken-fried steak, trout amandine, lobster tail and gourmet ice cream in flavors like coconut, rum raisin, praline pecan and peppermint. Each customer also received a complimentary barbecue sparerib.

Phillips enjoyed the pre-shift staff meals. Paying fifty cents each, employees gathered for everything from beef Stroganoff and fried chicken to liver and onions, as well as red beans with sausage and cornbread, before customers came in for dinner.

"The Farmer's Daughter was probably at its pinnacle in the '60s," Phillips said. "In the mid-'70s, when I was there, it was a prominent restaurant to be sure, but you could tell by the various dining rooms that were seldom used that it had seen greater days. This was likely due to increasing competition."

In 1976, Perry McCord of McCord-Condron & McDonald, Inc., purchased the Farmer's Daughter from Roach, who retained his three locations of Cattlemen's Steak House. The restaurant began operating under the corporation name of Farda, Inc., but closed shortly thereafter. The Traveling Salesman basement lounge later reopened as a separate establishment with a private entrance so it could operate until 2:00 a.m.

LONDON HOUSE

While the *Fort Worth Star-Telegram* described the decor as "Olde English" with an atmosphere "as pleasant as a roadside pub," the London House name was a bit misleading. Opened in 1967 at 4475 Camp Bowie Boulevard by Robert and Dell Pearson, the wood-paneled restaurant actually specialized in steaks, not English fare.

"Steak and ale are the specialties of the house," announced ads. Even the carnivorous, meat-centric menu was printed on actual steel meat cleavers, which were reported to sell for an expensive fifteen dollars each if customers wanted to take one home. The bill of fare was later printed with kitschy British cartoons on cardstock.

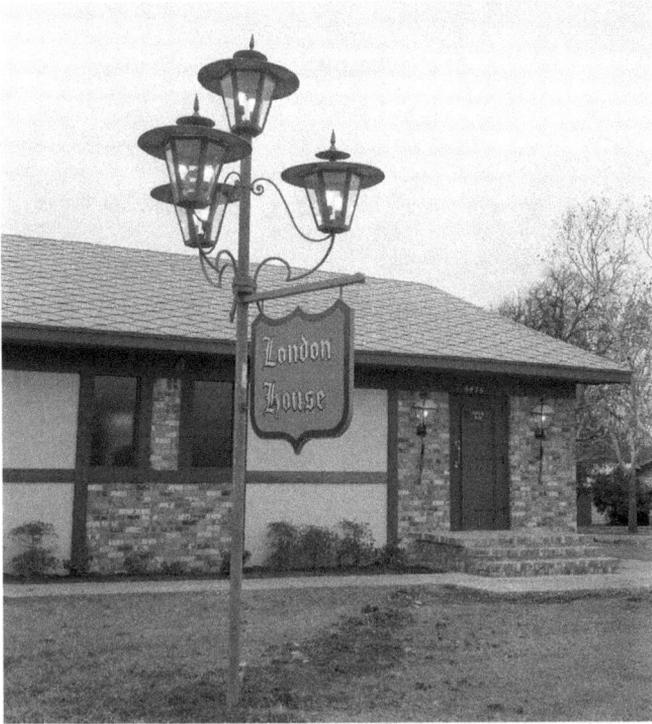

Left: The London House restaurant opened in 1967 at 4475 Camp Bowie Boulevard. *W.D. Smith Photography Collection, Special Collections, the University of Texas at Arlington Libraries, Arlington, Texas.*

Below: The London House, seen here in 1967, was described as "pleasant as a roadside pub" by the *Fort Worth Star-Telegram*. *W.D. Smith Photography Collection, Special Collections, the University of Texas at Arlington Libraries, Arlington, Texas.*

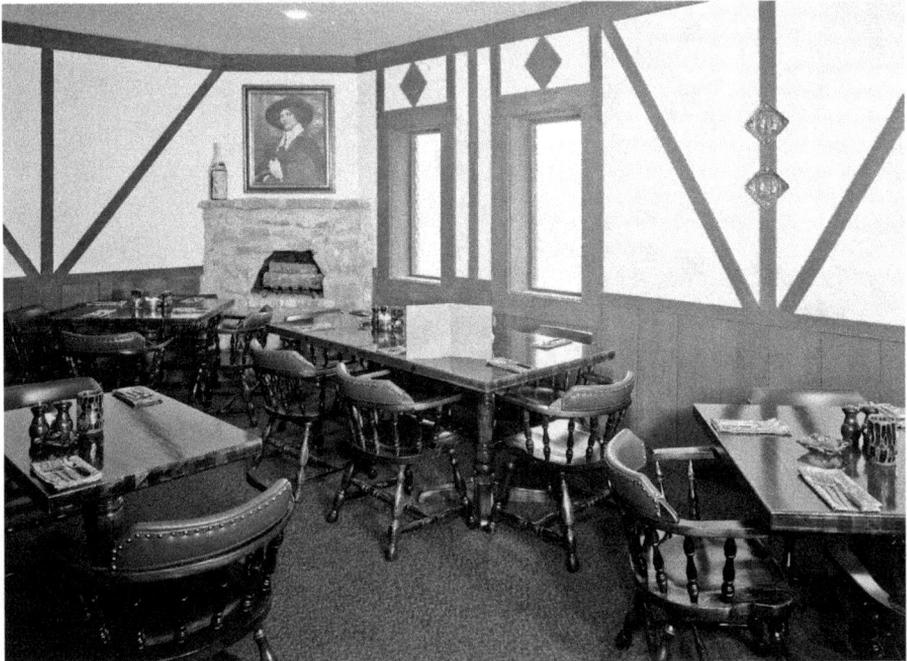

London House menu. *Dalton Hoffman.*

Dishes included rib-eye steak, Alaskan king crab, beef kabobs, "Canterbury mushrooms," the "Cambridge club" and shrimp on ice. Desserts were not to be missed, especially the hot-buttered apple pie with sweet brandy sauce.

The special-occasion destination touted itself as Fort Worth's "most intimate and romantic restaurant," with "soft lights and sweet music." A cozy fireplace set the tone for the venue that was very much intended to attract couples, many of whom visited to celebrate anniversaries, birthdays and first dates.

According to the *Fort Worth Star-Telegram*'s "Around Town" columnist in 1971, the London House was also known for hiring young and beautiful college students. Among the young staff was the handsome bartender Hal Board, who crafted cocktails between premed classes, and his girlfriend, Kay Winston, "the light of his eye, blond and petite," who was preparing for a career in clothing and textiles.

"Kudos to Bob Pearson, who steers this fine restaurant, for his sincere interest in these wonderful young people," wrote the columnist.

The menu evolved to become more casual, with hamburgers featuring house-ground beef, "Olde English" beef stew and tuna sandwiches. The update proved to be fateful. A 1981 *D Magazine* review said, "London House was once *the* place to take your wife or prom date for a big steak dinner. Times change, and so did this favorite, into a dumpy, dusty-cornered, old restaurant with unreasonably high-priced, tough steaks."

By 1983, the restaurant was closed, perhaps due in part to the rise in popularity of corporate chains with similar concepts, like Steak & Ale, which featured a "Kensington club" and several steaks in a similar dark, pub-like setting.

ZUIDER ZEE

When Bill Martin decided to open a seafood restaurant in landlocked Fort Worth in 1957, all he knew about seafood was that he liked raw oysters on the half shell. Shucking them was another story.

The first customer who ordered a half dozen oysters at his then-nameless eatery at 4850 White Settlement Road only got two, as reported by the *Fort Worth Star-Telegram*'s business writer Bill Foster. Martin was in the kitchen, frantically trying to open the other four, but he couldn't. At the time, the menu offered only raw oysters and peel-and-eat shrimp, the latter of which were boiled by his wife at home and brought to the restaurant.

"I didn't even have enough money to put up a sign outside," Martin told Foster in 1967. "And the hardest struggle at first was to make $11 a day to pay for a daily ad in the *Star-Telegram*."

The establishment had only twenty seats, but Martin kept at it, even expanding the menu to include gumbo, also prepared by his wife at home and delivered to the restaurant in a battered Chevrolet.

By 1960, he had managed to expand his namesake restaurant to three more locations and move his White Settlement Road original to prime real estate at 3419 West Seventh Street. He added "Zuider Zee" (Dutch for "South Sea") to the name. In 1962, he opened a location in Dallas, followed by one in Arlington and a second in Dallas. He eventually franchised locations across Texas and as far as Oklahoma City and Colorado Springs.

By this time, the menu included lobster flown in from Maine and clams from Philadelphia. Most fish came from Louisiana and the Texas Gulf Coast, delivered by Martin's personal fleet of refrigerated trucks. His wife no longer had to boil shrimp at home, and while he had mastered shucking oysters, Martin now had plenty of employees to do it for him.

"Customers used to come back to the kitchen on White Settlement and watch us drop the lobsters into the pot, just to make sure they were getting a fresh lobster," Martin told Foster. "I guess they trust us now."

He was the seafood king of Fort Worth throughout the 1960s, but in 1968, Martin decided to sell the restaurant chain to Ward Foods, Inc., a company out of New York. He was thought to have received stock and cash totaling around $5 million. Martin was to remain involved as an operations manager and later became a chairman as part of the deal.

Top: Zuider Zee advertisement, 1959. *From the* Fort Worth Star-Telegram.

Bottom: Zuider Zee advertisement, 1960. *From the* Fort Worth Star-Telegram.

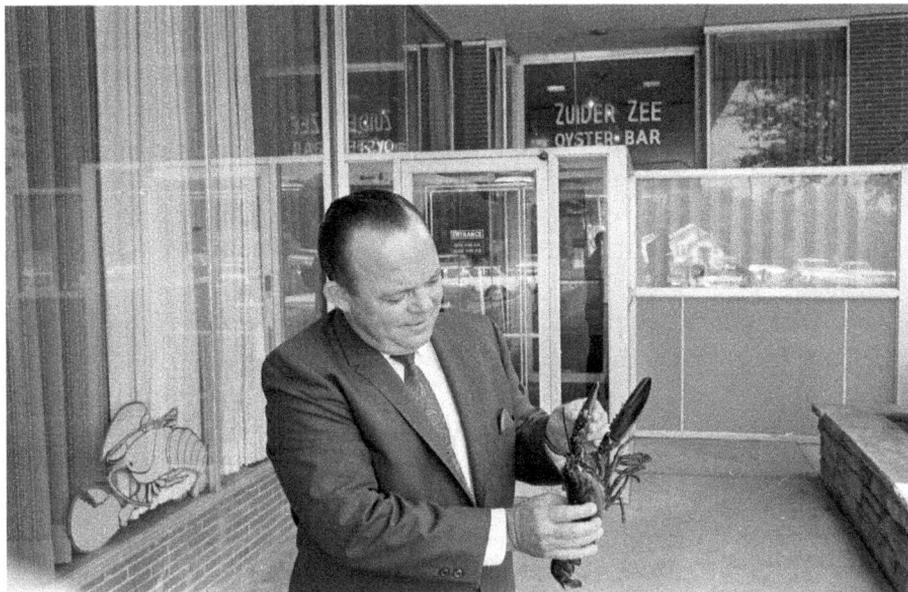

Every Wednesday & Thursday Zuider Zee serves all the Fresh Cooked Catfish you can eat. (For $1.69, kids 75¢)

Anytime is seafood time at Zuider Zee.
But when you're hungry for just The Catfish Fry, french fries, cole slaw and heaps of hush puppies, join us on Wednesday and Thursday.
The Catfish Fry is delicious.

Zuider Zee

We bring the ocean a little closer to you.

Fort Worth	Arlington	Dallas	Dallas
3419 West Seventh	1511 North Collins	318 Medallion Center	5427 Denton Drive
336-1691	274-1320	363-9135	634-0661

Top: Zuider Zee owner Bill Martin holds a live lobster outside his 3419 West Seventh Street location in 1967. *Fort Worth Star-Telegram Collection, Special Collections, the University of Texas at Arlington Libraries, Arlington, Texas.*

Above: Zuider Zee advertisement, 1972. *From the* Fort Worth Star-Telegram.

Left: Zuider Zee menu. *Dalton Hoffman.*

Plans were big for the Zuider Zee brand: forty more locations by 1970, two hundred fast-food versions of the restaurant nationwide and Zuider Zee brand frozen seafood in supermarkets. But by 1971, the Ward Foods conglomerate had let the expansion get out of hand. "The results were disastrous," the *Fort Worth Star-Telegram* reported in 1972. "Expansion was no longer careful; quality and service had slipped to a point that customers were completely cynical about the Zuider Zee image. Business slowed to a trickle."

Fort Worth–headquartered Executive Food Restaurants, Inc., bought the chain from Ward Foods in 1971 with the intention of reeling in the restaurant, so to speak, and launching a comeback with improved customer service and quality cuisine aimed at regaining longtime customers.

But the complicated story continued, resulting in variations of the original all over the place, many not involving Bill Martin at all.

Zuider Zee restaurants still existed across the country and throughout north Texas. The West Seventh Street location remained popular throughout the 1970s, and a North Richland Hills reincarnation opened in 1990 and drew crowds for several years.

Martin, meanwhile, opened Bill Martin's 2nd Edition in 1971 and grew it into yet another chain, with 3rd, 4th and a "Mini-Edition" later added. He sold the chain to Colonial-Jetton's, Inc., in 1979, and it carried on his popular Lobsterama tradition for a few years. But all locations closed by 1988.

In the mid-1980s, Martin opened Michael's Oyster Bar and Seafood Restaurant, named for his son-in-law. *Fort Worth Star-Telegram* food critic Bud Kennedy reported that the restaurant, built on Martin's ranch south of Burleson, was exactly like a Bill Martin's, "down to the menus and lemon pie and the tank of live lobsters by the door."

But with better seafood restaurants in town by this time, Kennedy wrote, "We only wish Martin/Michael's would change a little to keep up with the times and the competition. The emphasis on fried food is dated."

Perhaps that's what led to Martin's, and Zuider Zee's, ultimate demise.

At the end of his restaurateur career, Martin owned the Five Star Inn on Interstate 35 in north Johnson County along with an adjoining Zuider Zee restaurant. In 1989, he filed for Chapter 11 bankruptcy. The Fort Worth attorney who filed the bankruptcy petitions told the *Fort Worth Star-Telegram* that Martin owed more than $1.9 million to a Fort Worth bank.

"People remember Zuider Zee for the catfish breading and of course the stick hushpuppies. They made stick hushpuppies before they were

the cheap, frozen variety," said Kennedy in a speech for the Fort Worth Library about the city's iconic restaurants. "If Bill Martin's opened today, we wouldn't consider it a great seafood restaurant. But people always loved it back then."

ITALIAN INN

When the Italian Inn, "home of the singing waiters," closed its doors in 2013 after more than forty-five years in business, most customers didn't realize that the Ridglea landmark—lovingly laden with graffiti inside—was merely a spinoff of the first.

The saga of two fellows who aligned to bring Italian food to Fort Worth began years before, in East Fort Worth, not West.

Sid Smith and Armand Jones, both employees of the radio station WBAP, partnered to open the original Italian Inn in 1953. It was Jones's idea. After passing through Italy as a GI during World War II, he fell in love with Italian fare and convinced Smith to join him in the restaurant endeavor.

According to Mike Nichols's book *Lost Fort Worth*, it was another fellow WBAP employee, Bobby Peters (who hosted a children's show), who told the duo about a dilapidated house for rent that fit their tiny budget. It was located on East Lancaster—back then, a bustling thoroughfare.

"We each borrowed $600 to start the Italian Inn on East Lancaster," Jones told the *Fort Worth Star-Telegram* in 1967. The two men, along with their wives, did their own painting and carpentry, bought a used stove and a secondhand refrigerator and laid tabletops over old sewing machines for dining. Outside, an "opening soon" sign was erected that proclaimed, "No Hamburgers. No Bar-B-Q. Just Real Good Spaghetti."

Flickering candles were added, and food was served in enclosed booths. The concept was a hit.

"When the Italian Inn opened on November 13, 1953, the kitchen ran out of food in three hours," Nichols wrote. "Word got around. And lo, in Cowtown, the multitudes did put down their Dairy Queen double cheeseburgers and their plates of ribs."

Italian food was mostly foreign in Fort Worth before the Italian Inn. According to one *Fort Worth Star-Telegram* report, an early customer asked for ice cream on top of the "new pizza pie entrée."

Italian cuisine was also served at Margie's Italian Gardens, which also opened in 1953 and still operates today under different ownership. But

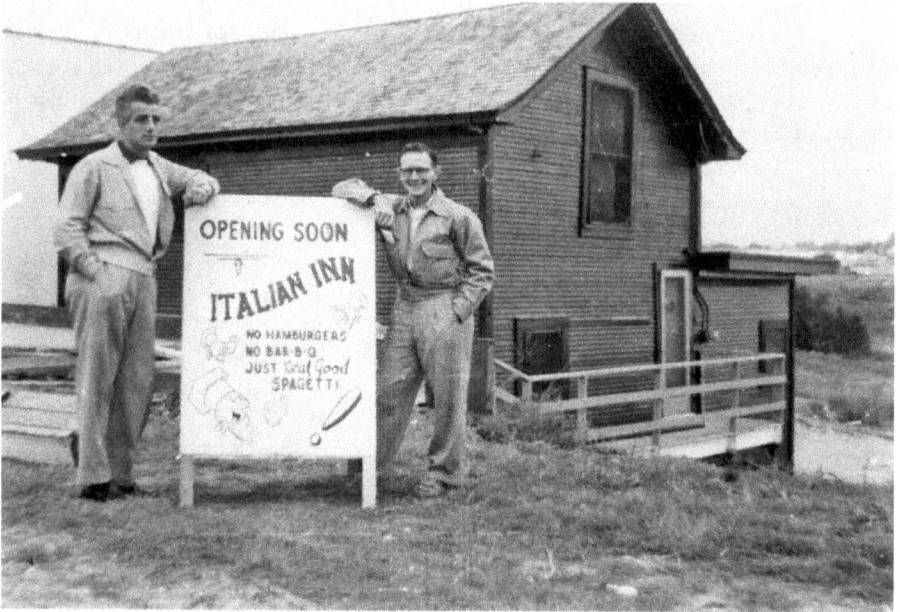

Above: Chef Mangano (*left*) and Italian Inn co-owner Sid Smith (*right*). The restaurant opened on East Lancaster Avenue in 1953. *Jan Shaffer.*

Left: Italian Inn menu jacket, circa late 1950s. *Jan Shaffer.*

Margie's was located on the outer west edge of Fort Worth on Highway 80 in a prairie and hardly considered competition.

In Italian Inn's early years, owners went through a few chefs before deciding to create their own recipes for future chefs to follow. In Nichols's book, Jones said he hired an authentic Italian chef with a Brooklyn accent who was a very good cook, but he would stomp on his hat and quit six to eight times a day.

A Mexican chef was let go after his meatballs began to taste like enchiladas, thanks to cumin he'd sneak into the kitchen.

The menu eventually evolved to include antipasto salads, veal scaloppini, ravioli, chicken cacciatore, cannelloni and an extensive wine list. A lively atmosphere was created with the addition of a player piano, and the restaurant capacity was later increased to include three levels of dining. The private booths enclosed by swinging doors were popular in one dining room, where countless couples celebrated anniversaries, marriage proposals or just romance in general. It was in these booths that the tradition of leaving one's mark at the Italian Inn began, be it via a permanent marker, a pocketknife or nail polish.

"The Italian Inn was an East Side institution, an alternative to drive-in restaurants like the Clover, fast-food chains like Griff's and the ubiquitous Dairy Queen," said Nichols, who lived in East Fort Worth from 1950 to 1971. "It was a real go-inside-and-sit-down-and-be-waited-upon adult restaurant where you took a date when you wanted to impress her. The food was good. Better yet, the food was affordable. And *still* better yet, the booths offered all that privacy. Sometimes we forgot to eat."

In a 1991 Italian Inn ad printed in the *Star-Telegram*, it was claimed that one man proposed to all five of his wives in the restaurant's booths. "In different booths of course," the ad said.

Additional restaurant locations followed for Jones, Smith and their wives, including the Italian Inn in Ridglea in 1967. But ownership of all eateries was divided once Jones and Smith discontinued their partnership.

Jones retained the original location, which later went to his wife, Anita, upon their divorce. Ads in the early 1970s invited customers to "visit Anita Jones' old original Italian Inn" for two-for-one spaghetti and meat sauce on Tuesday nights.

After Anita died from a heart attack suffered at the restaurant in 1975, the Italian Inn lived on for two more decades, eventually closing in the mid-1990s.

Nichols later became curious of the fate of the restaurant's building and scheduled a visit after learning it had become the home of a motorcycle club. "Gone were the booths, the piano, the celebrity photos," Nichols wrote on his blog, *Hometown by Handlebar*. "No red checkered tablecloths. No candles stuck in wax-encrusted wine bottles. Any ambiance the place had was certainly not that of a fifties restaurant."

But Nichols was led to a storage room in the back where, stacked on the floor, were a few graffiti-covered wooden booth doors. The motorcycle club cofounder let him have a pair, and today they serve as the top of his breakfast table.

FINE DINING AND SUPPER CLUB SWANK

White tablecloth dining was primarily limited to country clubs before restaurants like the Carriage House, Cross Keys Restaurant and Old Swiss House brought fine dining to the masses. Chefs like restaurant icon Walter Kaufmann helped educate Fort Worth's culinary palate with European dishes many diners had never heard of before, much less tasted.

And while there were never many supper clubs in Fort Worth that became longtime mainstays, the swanky social settings always had a seemingly high-class image, attracting well-dressed patrons who came not only to eat but also for pre-dinner cocktail hour and live entertainment afterward.

CROSS KEYS RESTAURANT

"A new adventure for you in gracious dining," promised an ad for Cross Keys Restaurant in 1955, the year Neal Hospers and Frank Carvey Jr. partnered to open the country club–inspired restaurant at Eighth and Pennsylvania Avenues in a turn-of-the-century mansion built by a pioneer cattle family. With fourteen rooms, cream brick and wood-paneled walls, the home was converted to feature a main dining room and four individually decorated private dining rooms upstairs—the Williamsburg Room, Eastshire Room, Westshire Room and the Ship's Log.

Carvey and Hospers were no strangers to fine dining and exquisite customer service, with Hospers gaining a reputation for his own particular

a new adventure for you in *Gracious Dining*

FORT WORTH'S
Most Distinctive Restaurant

Open for Dining
This Evening at 5:00

At Cross Keys, a name reflecting hospitality and fine food for nearly three centuries, you will enjoy dinner amid an atmosphere of Old English and Early American tradition. Superb food, expertly prepared with the connoisseur in mind, will be served in the main dining rooms and also in the four individually decorated private dining rooms upstairs. We invite you to visit Cross Keys for a new adventure in fine dining.

————Private Dining Rooms————

● WILLIAMSBURG ROOM ● EASTSHIRE ROOM ● WESTSHIRE ROOM ● THE SHIP'S LOG

Cross Keys
RESTAURANT
EIGHTH AT PENNSYLVANIA

Neal Hospers FOrtune-1792 Frank Carvey, Jr.

Left: Cross Keys advertisement, 1955. *From the* Fort Worth Star-Telegram.

Below: Cross Keys restaurant, located at Pennsylvania and Eighth Avenues, 1955. *Fort Worth Star-Telegram Collection, Special Collections, the University of Texas at Arlington Libraries, Arlington, Texas.*

brand of "hospertality" in the hotel business and Carvey learning about country club management through his father, Frank Carvey Sr. They both belonged to the Catering Executives Association of Fort Worth, and each served terms as president.

Inside the dining room, candelabra chandeliers hung from the ceiling over white linen–covered tables. Two large, English-style keys were positioned in an "x" on a brick fireplace set against patterned wallpaper.

Menu items included a filet mignon and lobster thermidor special, labeled "another first in Fort Worth," served with a baked potato, salad and bread for $4.25. Other unique items included a beef Stroganoff dinner for two with sherry-topped turtle soup and rosé wine for $4.95 and flaming crème de menthe for two served over vanilla ice for $1.50.

Cross Keys locations followed in Midland and Wichita Falls. The original moved to new quarters in 1962. Located at 500 Summit Avenue, the new

Cross Keys

Restaurant

Westchester Square
FORT WORTH

Dinner at Cross Keys

All Entrees Listed Below Include:
SALAD A LA HOSPERS† OR SALAD WITH YOUR CHOICE OF DRESSING, BAKED POTATO, ASSORTED BREADS, COFFEE†, TEA OR MILK

CHARCOAL BROILED STEAKS

Small Filet Mignon (6 oz.)	2.95
Top Sirloin Club (11 oz.)	4.25
T-Bone (8 oz.) Yearling	2.75
Large Filet Mignon (10 oz.)	4.25
T-Bone (16 oz.)	3.95
Small Club (7 oz.)	3.25
KC Sirloin Strip (15 oz.)	4.95
Chateaubriand SERVICE FOR TWO OR MORE	5.25 (Per Person)

THE CROSS KEYS SPECIALTY
PRIME RIB of BEEF au JUS . 3.75
Served with creamy horseradish sauce and Yorkshire Pudding.
(THE DIAMOND JIM BRADY CUT — for the real stout hearted .. 4.95)

OTHER SPECIALTIES

Beef en Brochette	2.95
Le Coq Au Vin	2.65
Filet of Fresh Red Snapper	2.95
Lobster Thermidor	4.25
Shrimp de Jonghe	2.95
Broiled Chicken a la Carvey	2.65
Veal Cordon Bleu	2.65

Left: When Cross Keys Restaurant opened in 1955, the country club–inspired restaurant promised a "new adventure for you in gracious dining." *Dalton Hoffman.*

Right: Cross Keys menu items included a filet mignon and lobster thermidor special, promoted as "another first in Fort Worth." *Dalton Hoffman.*

space featured an expansive dining room that could seat 275, along with moveable dividers that could split the space into private party rooms. Hospers and Carvey aimed to combine functionality with the atmosphere of the old Cross Keys. The interior decor was described as early American and old English with gas lights, crystal chandeliers and shuttered windows with leaded glass panes. An updated menu featured prime rib and French dishes. The restaurant became popular for rehearsal dinners, private parties and special-occasion dining for Fort Worth's elite.

The restaurant duo didn't stop there. Other openings included golf club–inspired Fairway Cross Keys, featuring the elegant Uno Mas Club on the first floor. Hospers also stayed involved in the hotel business but eventually sold his half of Cross Keys to Carvey in the 1970s. He bought it back just before Carvey retired from the restaurant industry in 1977 and started a career in commercial real estate.

But they wouldn't stay apart for long. In 1979, Hospers and Carvey united once again to reopen their Cross Keys restaurant as DeMars, a combination of the last names of Bill Martin, Zuider Zee's founder, and Louise Deyo, a former schoolteacher, who would both serve as the restaurant's management team. The short-lived concept was much more casual in focus, as the specialty was chicken-fried steak.

MAC'S HOUSE AND CARRIAGE HOUSE

"All we really wanted was to be able to get a good steak on Camp Bowie," Willis McIntosh told author Renie Steves in her 1993 cookbook *Fort Worth Is Cooking!*

The successful restaurateur, an Arkansas native who came to Fort Worth with his family at the age of fifteen, was referring to his first restaurant venture, the Carriage House, opened in 1959 at 5136 Camp Bowie Boulevard. McIntosh partnered with Roy Pope, owner of the West Fort Worth grocery and market that bears his name to this day, to open the white linen tablecloth establishment—one of the first in Fort Worth outside of country club dining.

McIntosh was no stranger to quality meat. He spent twelve years at Safeway as a butcher and then meat market manager before landing behind the premium meat counter at Roy Pope Grocery.

The restaurant, outfitted in woods and shades of green, initially seated seventy-five people and quickly gained a reputation for its garlic butter

The Carriage House

Fine Steak Dinners
Without Extravagance

5136 Camp Bowie Boulevard
Fort Worth, Texas

Thanks...

...AS YOU LEAVE
we cherish the hope that
your visit to the Carriage
House has been most enjoy-
able. We have tried to give you
gracious dining without extrava-
gance...a sample of real "Texas
Cooking" and Hospitality. Please return
to us soon and bring your neighbors.....

Left: The Carriage House was opened in 1959 by Willis McIntosh. *Dalton Hoffman.*

Right: The back of a Carriage House menu. *Dalton Hoffman.*

escargot and cracked pepper–crusted Kansas City sirloin, as well as its brandy ice cocktail blended with dark crème de cacao and French vanilla ice cream. The drink helped put the restaurant on *Esquire* magazine's list of one hundred best bars.

"This old standby offers a refreshing retreat from area steak houses that are big enough to accommodate basketball tournaments," wrote *D Magazine* in 1981. "The atmosphere in the two small crystal-laden dining rooms is not quiet, but it is relaxed nevertheless. The steaks are still the safest selections, and ours were prepared exactly as ordered."

The Carriage House bar was also known for "McIntosh's girls," the first nude portraits to be hung publicly in town outside of museums.

It was the place where big-shot executives and oil tycoons made deals; young men took their girlfriends to propose; and hundreds of couples celebrated anniversaries, birthdays and other special occasions.

With the Carriage House thriving, McIntosh and Pope bought the House of Mole in 1968 from owner Howie Wrentmore, who had opened what was boasted in ads as "Fort Worth's most interesting steak house" in 1953.

Located at 2400 Park Hill Drive at Forest Park Boulevard, the House of Mole was newly renovated in 1967 with brand-new carpeting and seating arrangements, a new color scheme and updated lighting. Wrentmore, a Thoroughbred horse enthusiast who decorated his restaurant with racing silks, wanted to retire and travel with his wife, Florence. Their first adventure was a six-month trip to Canada.

"A word of explanation" read the House of Mole menu. "'Mole (pronounced molay) Adobo,' one of the countless mole dishes, is a recipe as old perhaps as any food preparation in Mexico. An intricate, time-honored blend of sweet peppers, onions, tomato, chilies passilla, olive oil, clove,

Left: House of Mole menu. *Dalton Hoffman.*

Below: House of Mole ad, 1954. *From the Fort Worth Star-Telegram.*

Mac's House dining room, 1987. *Fort Worth Star-Telegram Collection, Special Collections, the University of Texas at Arlington Libraries, Arlington, Texas.*

nutmeg, and chocolate was found by food lovers in Mexico long ago most aptly to accent the delicate mildness of chicken, the hearty flavor of ribs. By no people are ribs and chicken so championed as by Texans…no way are they more delicious than served a' mole."

When Pope passed in 1968, McIntosh bought out his interest. His son Kent McIntosh managed the House of Mole, which was later called Mac's House. Described as "comfortable and contemporary" by *Texas Monthly* in 1973, the restaurant kept Wrentmore's Central American mole sauce recipe, at least for the first few years.

"You really feel like you're in a country club—or an antebellum mansion—because attendants in jackets are buzzing everywhere, freshening water and coffee, emptying ashtrays and grabbing each piece of cellophane the minute you unwrap the crackers," wrote *Star-Telegram* food writer Bud Kennedy in 1987. Dinners at that time came with two onion rings and Mr. Mac's house salad. While House of Mole was known for its signature salad made with iceberg lettuce, toasted sesame seeds and grated Romano cheese, Mac's salad (also served at the Carriage House) was regarded as the best in town by many.

"The salad itself would make an excellent lunch," wrote Kennedy in his review. "[A]nything with this dressing on it would be great."

But not even the salad could save both the Carriage House and Mac's House from closing under Chapter 7 bankruptcy in 1993. The restaurants shuttered despite McIntosh's efforts to bring in new culinary talent and update the menu with more sensible choices.

"We just needed more butts in the seats," McIntosh told the *Fort Worth Star-Telegram.*

McIntosh's granddaughter and restaurant manager, Kimberly McIntosh, provided a more thought-provoking comment to the paper, one that described a growing trend in Fort Worth's culinary scene and beyond.

"Maybe the white-tablecloth restaurants are all dying out."

The Carriage House Brandy Ice
Serves one

1 ¼ ounces brandy
¾ ounce dark crème de cacao
2 scoops French vanilla ice cream

Recipe by Carriage House bartender Richie Todd, as featured in the October 1974 issue of *Texas Monthly*.

Mr. Mac's Salad
Serves twelve

1 cup lemon juice
1 teaspoon Lawry's seasoned pepper
½ teaspoon dry mustard
½ teaspoon salt
1 teaspoon freshly ground pepper
1 tablespoon Worcestershire sauce
dash of Tabasco sauce
¼ cup grated onion
1 hard-boiled egg, grated
2 cups safflower oil
½ pound mushrooms, sliced
2 cups grated Swiss cheese

Combine first nine ingredients. Whisking constantly, pour oil in a thin steady stream. Tear romaine, Bibb and radicchio lettuce in bite-sized pieces. Mix with mushrooms, cheese and dressing.

Excerpted from *Fort Worth Is Cooking!* by Renie Steves.

OLD SWISS HOUSE

Sights, sounds, smell and taste—those were the specific customer sensory points Walter Kaufmann wanted to tune into when he opened the Old Swiss House on Camp Bowie Boulevard in 1964.

"I wanted the restaurant to be a place where the minute you walked in, you liked it," said the sparkly-eyed Swiss immigrant at eighty-seven years old, decades after he helped shape Cowtown's culinary palate in sophisticated fashion. "I wanted to activate all of your senses."

Upon his arrival in Fort Worth, the classically trained chef quickly garnered a loyal following after stints at Ridglea and Colonial Country Clubs. His intention was always to open his own restaurant, he said, where he could control everything from the ingredients and presentation to the decor and background music. His established country club clientele "helped him tremendously," he said.

"I didn't have to advertise."

Initially, the Old Swiss House was intentionally kept small with minimal seating. When demand dictated it, Kaufmann would add approximately twenty more seats at a time. But on slower evenings, if needed, he could close off portions of his dining rooms with luxurious curtains to keep the appearance of a continually packed house.

"People would say, 'If you go to the Old Swiss House, it's always full,'" he said. "That helped me a lot."

Old Swiss House chef and owner Walter Kaufmann (*right*). *Walter Kaufmann.*

Swiss-born chef Walter Kaufmann wanted to tune into "sights, sounds, smell and taste" when he opened the Old Swiss House on Camp Bowie Boulevard in 1964. *Walter Kaufmann.*

It was Fort Worth's premier venue for celebrations, be it birthdays, anniversaries or burgeoning business deals. The Old Swiss House exuded world-class ambiance with plush tapestries in hues of red, intimate lighting, occasional vocals by Texas Christian University student (and later Tony Award–winning actress) Betty Buckley and upscale dishes like chateaubriand steak, rack of lamb and veal Oscar.

"Swiss owner is chef—and perfectionist," said *Texas Monthly* magazine's dining guide in 1974. "Veal dishes here can stack up against the best anywhere; try veal Oscar (with lobster). Superb fresh salmon in season. Excellent service. Good house wine. Reservations necessary."

It was where local businessmen brought out-of-town guests and where prominent Fort Worth dignitaries, including philanthropist Mercedes Bass, were loyal to their preferred servers.

"Mrs. Bass' secretary called once and said she had eight people coming in," recalled Kaufmann. "'She'd like Morris, your head waiter, to wait on them,' her secretary said. It was his day off. She said, 'Walter, can you find him? Can you call him?' I said, 'If I find him, he'll come in a minute.'"

Kaufmann never reached Morris, so Bass changed her reservation to a day that accommodated Morris's schedule.

"That tells me it wasn't just the food," Kaufmann said.

But it was also Kaufmann, who demonstrated exceptional customer service by example. With his tall chef hat and neatly buttoned chef coat, he would work the dining room with confidence and panache almost as much as he worked in the kitchen. He knew every regular customer's name, including their children's names and the name of the family dog. In the 1960s, Kaufmann was iconic in Fort Worth as the city's first bona fide chef. He was the celebrity TV chef before there were TV chefs.

"Most people had never seen a live chef," Kaufmann said. "They'd only seen a chef on a can of Chef Boyardee."

From left to right: Barbara Walters, Walter Kaufmann and Mrs. John Connally at Old Swiss House. *Walter Kaufmann.*

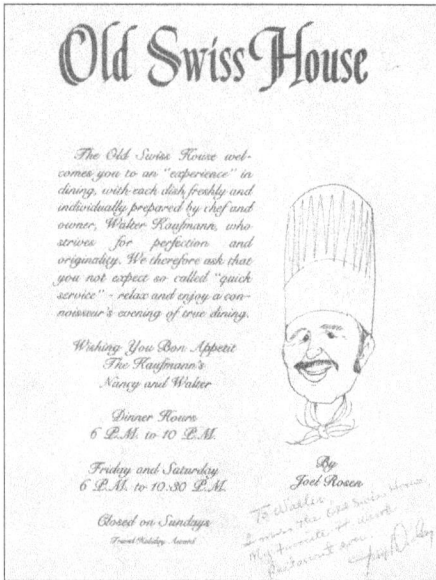

Walter Kaufmann was a local celebrity chef before there were TV celebrity chefs. *Walter Kaufmann.*

Kaufmann's unmatched menu, with its freshness, distinctiveness and high-quality ingredients, also played a huge role in the restaurant's success.

"When I opened the Old Swiss House, I had no competition," Kaufmann said. "Not because I was that good and nobody could be as good as I was, but because customers couldn't go anywhere else to get the items I had on my menu. I was competing with Mexican food, steak and baked potatoes."

On one occasion, a customer questioned the freshness of the restaurant's salmon. Kaufmann immediately knew how to address the issue.

"I took the salmon, head on and all, and went to the table. I said, 'You asked about the salmon?'"

A presentation of fresh fish to the restaurant dining room was unheard of before in Fort Worth. Word spread about the incident, and Kaufmann considered it free advertising. More people began ordering the salmon.

"The GM at Ridglea Country Club once said, 'I don't know how in the hell people still go to your Swiss House. You have the same menu you had thirty years ago,'" Kaufmann said. "I told him, 'I'm glad you mentioned that,' because the timing was right to try to change it a bit."

So Kaufmann removed an item that wasn't his favorite—breaded veal with mushrooms and spaetzle.

"My head waiter came to me and said, 'I have a customer who's very unhappy,'" he said.

That customer was Dr. Bobby Brown, a former New York Yankees third baseman and retired Fort Worth cardiologist. Brown had never had any other dish at the Old Swiss House, and Kaufmann decided he'd better not try to make any more changes.

But when Interstate 30 expanded, Kaufmann was forced to make his biggest change to the restaurant yet. He had to move to a location on the Trinity River, and the Old Swiss House was never the same

Old Swiss House Specialties

Escalopes de Veau "Oscar" .. 16.00
Northern Veal Sauteed in Butter, Topped with Crabmeat and Hollandaise, Asparagus

Escalopes de Veau Sautee au Champignons 14.50
Veal Sauteed in Butter, Topped with Fresh Mushrooms and Served with Assorted Vegetables

Filet Mignon de Boeuf - Oscar 16.00
Tenderloin Steak Topped with Crabmeat and Hollandaise, Asparagus

Escalopes de Veau St. Moritz 14.50
Northern Veal Sauteed in Butter, Topped with Ham, Creamed Mushrooms and Swiss Cheese, Spatzli

Emince de Veau Zurichoise 12.50
Tender Minced Veal Served in a White Wine Sauce with Mushrooms, Spatzli

Filet Mignon Sauté King Henvy IV 14.95
Small Filet, Fresh Mushrooms and Artichokes Topped with Sauce Bearnaise

La Bouquetiere de Legumes Sur Plat 10.50
A Plate with an Assortment of Vegetables

Filet Goulash a La Minute 13.50
Cubes of Tenderloin Sauteed with Fresh Mushrooms, Served in Pungent Burgundy Sauce, Spatzli

Chicken Breast a La Kiev 12.50
Breast of Capon Filled with Spiced Butter and Served with Wild Rice

Tranche de Foie de Veau a L'Anglaise 12.50
Grilled Calf's Liver with Onion and Bacon

Carre D'Agneau Persillade 35.00
Rack of Lamb with Parsley, Bread Crumbs and Mustard

All Dishes are Served with Fresh Vegetables, Potatoes and Salad

Ask Your Waiter for Today's Specials

Desserts

Banana Foster for Two 6.00
Crepes "Gigi" with Strawberries for Two 6.00
Cherries Jubilee for Two 6.00
Strawberries Grand Marnier 5.00
Creme Caramel 2.00 Chocolate Marmot .. 2.50
Parfait Tia Maria . 2.50 Chocolate Mousse ... 2.00

Old Swiss House menu items included upscale dishes like chateaubriand steak, rack of lamb and veal Oscar. *Walter Kaufmann.*

"I believe it was 1984 when the economy went down," Kaufmann said. "I was on the river, which seated 100. I didn't want a place that big. The people that used to come in once a week started coming in once a month. The hardship started. I opened for lunch to try to keep my people working. That's a long day."

The Old Swiss House closed in 1994 when Kaufmann was sixty-five years old. He was ready, he said, but still did some restaurant consulting with the Balcony and, later, Bistro Louise. He remains involved in the Fort Worth culinary scene and is considered a restaurant icon by many of Fort Worth's chefs today.

"To succeed, it's not just talent," Kaufmann said. "It's lots of luck. And I had the luck."

Old Swiss House Cold Cucumber Soup
Serves six

4 large cucumbers
4 tablespoons butter
2 large yellow onions, sliced
4 cups chicken stock
½ cup flour
1 cup each milk and cream
1 teaspoon lemon juice
1/16 teaspoon cayenne pepper
¼ teaspoon salt (optional)

Peel, seed and chunk the cucumbers. Sauté onions until transparent and add cucumbers and chicken stock. Boil, and then simmer until cucumbers are soft. Blend flour and milk together until smooth. Whisk into soup and let boil for ten minutes. Press soup and cucumbers through a sieve or food mill. Add remaining ingredients. Refrigerate. Garnish with fresh chives.

Excerpted from *Fort Worth Is Cooking!* by Renie Steves.

TOWN PUMP AND BURGUNDY TREE

Between his local chain of Lone Star drive-ins and coffee shops, Ol' South Pancake House, Japanese Palace and several nightclubs and lounges, Dave Benson became famous in Fort Worth for his restaurant and entertainment enterprise from the 1940s through the early 1980s.

He first arrived in Fort Worth in 1943 after leaving his hometown of Hebbronville in south Texas.

"He was the youngest in the family," said his daughter Pam. "His car broke down with his buddy and they decided to stay. This was during wartime."

Benson opened the 609 Club at 609 South Jennings Avenue. It was there he met his future wife, a sixteen-year-old who worked for him as a cigarette girl. Pam said her mother didn't tell her parents she was working at a bar. The two got married and later went to Alaska for a brief stint while he worked in the construction business. Returning to Fort Worth and ready to make his mark, Benson began opening restaurant after restaurant.

"Back in the '50s, after the war, things were just popping," Pam said. "Business was great. He was an entrepreneur, and that's how he taught me. He said, 'You just handle it and you just go do it.'"

In 1957, Benson opened Town Pump at 1015 University Drive. It was advertised as Fort Worth's first public piano bar, where "music and fellowship are unexcelled."

While mostly considered a bar and lounge, the Town Pump, with its clever name and swanky atmosphere, soon represented an authentic supper club, where folks came for dinner but stayed for live music. The term "supper club" was eventually added to the venue's title. There was entertainment nightly and a menu that featured steaks and seafood, like bacon-wrapped fillets, twin lobster tails, fried shrimp and frog legs. A noon buffet was eventually added and ran for $1.45 in 1971.

"Town Pump was the first liquor-by-the-drink place," said Pam. "We had a revolving stage and a spiral staircase. It was cocktails and blues."

But in 1976, Benson was ready to revamp the successful concept.

"I still don't know if I was dumb or not. I just figured it was time to change," he told the *Fort Worth Star-Telegram* in 1981. "I saw all the new hotels and country clubs drawing business. I wanted the younger crowd to keep coming in."

So he remodeled the space and greatly expanded the menu to include omelets, crepes, onion soup and countless cocktails. The new name was Burgundy Tree.

The

TOWN PUMP
SUPPER CLUB
Invites You to Enjoy Beautiful

NOON BUFFET $1.45
Prepared by Chef James Warren and
Served Daily 12 Noon Till 2 P.M.

1015 UNIVERSITY DRIVE 335-2514

Left: Town Pump advertisement, 1971. *From the* Fort Worth Star-Telegram.

Below: The Burgundy Tree. *Pam Benson.*

"We went over to a place in Dallas and kind of copied their ideas," Pam said. "We had the ladies wear long dresses. And everything was served in a skillet. We had French onion soup and duck. It was kind of an eclectic menu."

Regarding the tree in the title, there was one inside, Pam said. Decor included colorful fabrics and antique furnishings.

"It drew a nice crowd," Pam said. "All of the car dealerships were on Seventh Street. They went for happy hour, and girls would be there. It was a happening place. That's where you met after work. Coming from downtown Fort Worth, you stopped at the Burgundy Tree and had a drink. The bar was packed at five o'clock. We had a huge happy hour buffet; mainly cheeses and finger foods just to keep you from getting too drunk."

The restaurant would also feature ten-cent drinks for ladies at random times.

"That brought them up there because you never knew what day that was going to be on," Pam said.

But the restaurant burned badly in 1984, forcing its closure. Benson died in 1985, ending his era of establishing unique restaurants and bars in Fort Worth. Pam had the Burgundy Tree location rebuilt as David's Restaurant & Bar, serving breakfast, lunch, dinner and late-night cocktails daily. But the economic downturn of the mid-1980s resulted in its closure.

"I had to tell people I got my MBA and PhD in the business of hard knocks," said Pam, who owns Japanese Palace today. "It was a very difficult but an extreme learning experience."

Dos Gringos moved into the space by 1990, but it closed in 2015. The building was bulldozed shortly thereafter to make way for new development.

STILL FEEDING FORT WORTH

The clamor in Cowtown over each flashy new restaurant is almost deafening, but according to widely cited research by a professor from Ohio State University, around 60 percent of restaurants fail in the first three years. This stat varies across the country and very well may have changed since the study was conducted in 2003. But opening a restaurant, and staying open, requires much more than being a good cook. Quality and consistent service are key, as are skilled business management and an appealing concept, especially in today's restaurant climate, where eateries come and go faster than potential patrons can make reservations.

It's a wonder that any make it to a decade, much less—in the case of some of Fort Worth's oldest establishments—to eighty years and beyond. In a book dedicated to Fort Worth's restaurant past, there are many precious places still in business worth mentioning, because these venues stood alongside the lost restaurants of yesterday and still feed the generations of today. Whether it is their comfort cuisine, worn yet welcoming atmospheres or dedication to superb service, they've steadily stood the test of time.

ANGELO'S BAR-B-QUE

2533 WHITE SETTLEMENT ROAD, FORT WORTH
817-332-0357
ANGELOSBBQ.COM

What started in 1958 as a four-table restaurant has grown into an institution of Texas barbecue and a destination for many out-of-towners. Angelo George's son Skeet and grandson Jason now run his namesake barbecue joint, and they can usually be found seated to the right of the bar with regulars who've been visiting for decades. Angelo, who passed in 1997, was known for always entertaining his guests, including casino giant Benny Binion, who apparently once tried to lure Angelo to Vegas to open a Texas barbecue joint. The story goes that Angelo said no, asking where he would find enough hickory wood in the desert.

BAILEY'S BARBECUE

826 TAYLOR STREET, FORT WORTH
817-335-7469

J.T. Bailey worked as a navy cook before he opened his namesake downtown barbecue shack in 1931, the same tiny red brick building it still sits in today. The lunch-only spot is now run by his grandniece, Brenda Phifer, and she knows that her customers, mostly downtown workers, like to get in and out. She keeps the ordering line quick and efficient. The unspiced, oak-smoked beef is served sliced or chopped on soft buns and then packed into brown paper sacks. There's always a daily special that comes with chips and a drink, and smoked sausage, smoked turkey and spicy pulled pork are also available. Phifer says that, while competition is fierce, she hopes to carry on the Bailey's legacy for another twenty or thirty years.

CARSHON'S DELI

3133 CLEBURNE ROAD, FORT WORTH
817-923-1907
CARSHONSDELI.COM

Opened by Jewish immigrant David Carshon in 1928, originally in partnership with Morris Chicotsky's Houston Street meat market downtown, the deli has changed locations a couple of times but is still the only kosher deli in Fort Worth. Popular and unique menu items are split pea and matzo ball soups, polish sausage, smoked trout and the strawberry delight pie with sweet crumble topping.

JOE T. GARCIA'S

2201 NORTH COMMERCE STREET, FORT WORTH
817-626-4356
JOETS.COM

Opened in 1935 as Joe's Bar-B-Q and seating only sixteen, Joe T. Garcia's now serves around two thousand when the house is full. Jessie and Joe T. Garcia first owned a tiny grocery store at the same location, where local workers from the nearby meatpacking houses would visit for lunchmeats and sandwich items. Joe's barbecue was cooked in a charcoal pit, but it was the tamale, enchilada and taco plates that later drew crowds, including the likes of Jimmy Stewart and John Wayne. Construction on the world-famous patio wasn't started until 1970. The patio includes a pool Garcia's grandchildren grew up swimming in.

MEXICAN INN CAFÉ

MULTIPLE LOCATIONS
MEXICANINNCAFE.COM

Big-time gambler Tiffin Hall opened Mexican Inn in downtown Fort Worth in 1936 at the corner of Fifth and Commerce Streets, serving Tex-Mex on the first floor and gambling on the second. It was the cash from the card

games that kept the eatery afloat until Hall built his empire and opened more locations. The kingpin passed away in 1973, and the restaurant was later purchased by the same group that owns Spring Creek Barbeque and Shady Oak Barbeque & Grill. Ground masa is used to make soft, hot and fresh corn tortillas and addicting crispy fried corn chips that no doubt play a role in the restaurant's decades of success.

THE ORIGINAL MEXICAN EATS CAFE

4713 CAMP BOWIE BOULEVARD, FORT WORTH
817-738-6226
ORIGINALMEXICANEATSCAFE.COM

The thirty-second U.S. president, Franklin D. Roosevelt, ate here so frequently during his visits to Fort Worth that a menu item was named for him. It offers one beef taco, one cheese enchilada and one bean chalupa, topped with two sunny-side up eggs, if desired. Originally opened by the Pineda family in 1926, the Original is now owned by Robert Self, who added partially covered patio dining in 2013. And while everything here seems to be covered in cheese sauce or chile con carne, the allure of no-frills Tex-Mex and quality margaritas still draws crowds.

PARIS COFFEE SHOP

704 WEST MAGNOLIA AVENUE, FORT WORTH
817-335-2041
PARISCOFFEESHOP.NET

The historic hangout's name came from its original owner, Vic Paris, who sold the restaurant to Gregory Smith not long after opening in 1926. Today, Greg's son Mike, owner and pie maker, can be found roaming the restaurant catching up with regulars. The Smith family's longtime, highly lauded breakfast and lunch café has been featured in the *New York Times*, in published travel guides and on the Food Network for its classic coconut meringue pie.

RISCKY'S

MULTIPLE LOCATIONS
RISCKYS.COM

Riscky's original Azle Avenue location, opened in 1927, is still operating after four generations of family ownership. The business started with Mary and Joe Riscky, Polish immigrants who opened Riscky's Grocery & Market and served barbecue lunch specials. Today, there are six barbecue locations, a burger joint and a steakhouse, which exists in the former Theo's Saddle & Sirloin Inn in the Stockyards. The saloon and inn establishment was built in the 1920s and is historically known for introducing Fort Worth diners to calf fries. The fries were kept on the menu when the Riscky family took over in 1993.

BIBLIOGRAPHY

Books

Cohen, Judith S. *Cowtown Moderne: Art Deco Architecture of Fort Worth, Texas.* College Station: Texas A&M University Press, 1988.

George, Juliet. *Camp Bowie Boulevard.* Charleston, SC: Arcadia Publishing, 2013.

McGown, Quentin. *Fort Worth in Vintage Postcards.* Charleston, SC: Arcadia Publishing, 2003.

Nichols, Mike. *Lost Fort Worth.* Charleston, SC: The History Press, 2014.

Pate, J'Nell L. *Fort Worth Stockyards.* Charleston, SC: Arcadia Publishing, 2009.

Steves, Renie. *Fort Worth Is Cooking!* Fort Worth, TX: Cuisine Concepts, 1993.

Magazines

D Magazine (September 1981).

Texas Monthly (February 1973, November 1973, August 1974, October 1974, July 2015).

Newspapers

Fort Worth Morning Register (1897).
Fort Worth Star-Telegram (1907–94).

Websites

"Closed and Forgotten Cowtown Eateries." Facebook. http://www.facebook.com.
"Fort Worth History." Fort Worth, Texas. http://fortworthtexas.gov/about/history.
Fort Worth Yesterday. www.fortworthyesterday.com.

Libraries and Historical Societies

Historic Fort Worth, Inc.
Special Collections. The University of Texas at Arlington Libraries. Arlington, Texas.
Tarrant Country Archives.

Interviews

Benson, Pam. Personal interview with author, March 3, 2017.
Kaufmann, Walter. Personal interview with author, January 20, 2017.
Massey, Steve. Telephone interview with author, June 14, 2017.
Miller, Jack. Email interview with author, June 1, 2017.
Moncrief, Mike. Email interview with author, June 2, 2017.
Murrin, Steve Jr. Telephone interview with author, June 8, 2017.
Nichols, Mike. Email interview with author, June 15, 2017.
Phillips, David. Personal interview with author, March 12, 2017.
Price, Betsy. Email interview with author, June 9, 2017.
Tucker, Tommy. Telephone interview with author, June 15, 2017.

INDEX

T

U

V

W

Y

Z

ABOUT THE AUTHOR

Celestina Blok has been writing about Fort Worth restaurants since 2005. A third-generation Fort Worth native, Blok writes a restaurant news column, cocktail column and recipe feature stories for *Indulge* magazine from the *Fort Worth Star-Telegram*. She also contributes to fortworth.culturemap. com, *Fort Worth, Texas* magazine and *Texas Highways* travel magazine and has written for the *Fort Worth Business Press*. Blok graduated with a degree in journalism from Texas Christian University and is also a graduate of the Culinary School of Fort Worth. She is also a fitness instructor and finds balance in writing, eating and exercising for a living.

www.ingramcontent.com/pod-product-compliance
Lightning Source LLC
Chambersburg PA
CBHW070833100426
42813CB00003B/599